ANCIENT IMAGES ON STONE

Ancient Images on Stone

Rock Art of the Californias

Preface Clement W. Meighan

Foreword Campbell Grant

With Essays by:

Frank Bock
Ken Hedges
E. C. Krupp
Frank LaPena
Georgia Lee
Clement W. Meighan
Mark Oliver and William D. Hyder
Gerald Smith
Wilson G. Turner
Jo Anne Van Tilburg

Compiled and Edited by Jo Anne Van Tilburg

The Rock Art Archive
The Institute of Archaeology
University of California, Los Angeles

The Rock Art Archive is part of the UCLA Institute of Archaeology, and is under the supervision of Dr. Clement W. Meighan, Director of the Archaeological Survey. Dr. Giorgio Buccellati directs the Institute. Dr. Ernestine S. Elster is Director of Publications.

Contents

To the ancient artists
Who, in primal and poetic beauty
Left a vision of a changing world
Upon the unyielding stone.

Acknowledgments

My personal acquaintance with archaeology goes back to my childhood in the Midwest and my mother's interest in "Indian things." Extensive travels since have taken me to numerous sites, in both the New World and the Old. I have followed an avocational interest along a wide network of paths and rutted roads and have learned, in the process, to ask what I think are some important questions.

This book has been a long time in process. The original idea grew out of all the questions asked by those who saw the exhibit, and by the realization that few people were well acquainted with this aspect of California history. From original idea to final product, however, was almost three years.

Clearly, this volume would not now be in print were it not for the generosity and social commitment of the Ahmanson Foundation. Dr. Franklin Murphy has had a long-standing and supportive interest in the Archive and its programs. I am personally grateful to Ms. Kathleen Gilcrest, Vice President of the Foundation, for her sensitivity to the issue of rock art preservation and for her openness to this project.

I should like to stress that most of what is done in rock art research by most people, while supported in principle by a number of institutions, is independent work. This book and the activities out of which it grew are no exception. While independent, the effort has not been a lonely one, and there are people who have given time, energy, warmth and support from the beginning. They have shared willingly of their expertise, information, personal libraries, and collections of photographs. Though largely an avocational field, rock art research is not an unprofessional one, and is enriched with dedicated and determined people. I think especially of Kathi Conti, Georgia Lee, Ken Hedges, and Wilson Turner.

Campbell Grant has provided a careful and patient reading of the entire manuscript. Ken Hedges, president of the American Rock Art Research Association, also read, critiqued, corrected, and advised with uncommon generosity. Their efforts are greatly appreciated.

At the National Park Service, David C. Ochsner and Susan J. Cadwallader have been creative in their support. Through their efforts, the initial exhibit produced another, much more far-reaching show, with increased potential impact.

William Seidel at the State Office of Historic Preservation and Martha Baker in Senator Alan Cranston's office have been most helpful, as has Alan Jabbour, Director of the Folklife Center, Library of Congress. The endorsements of U.S. Congressman Anthony C. Beilenson, Los Angeles City Councilman Marvin Braude, and State Senator Alan Sieroty are appreciated.

Since the very beginning, from the initial fundraising in 1979 through numerous other activities on behalf of rock art, I have gotten consistent personal support and

encouragement from some special friends. Frank and A. J. Bock, Rick Doremus, Jackie Dubey, Marty Gonzales, Jim Heaton, Ann and Tom Lockie, and Rita Yokoi have always had good ideas and words of encouragement. Clement W. Meighan, Director of the Archaeological Survey and of the Archive, provided unfailingly good direction. Ken Cohen trusted my taste and judgment sufficiently to lend his gallery space for the first exhibit, not quite sure what those pictures of "rock art" would really offer.

Special thanks to Mark Oliver for efforts made to insure good color quality and reproduction of the photographs, and to Carol Leyba of the Institute of Archaeology for her editorial assistance. A. J. Bock researched and produced the fine maps used to illustrate the text, and Kathi Conti contributed her lovely drawings. Charlotte Heth at the UCLA American Indian Studies Center was most helpful in working with me to insure a native American contribution to this book. Thanks to Rick Hauser for his wonderful phrase "consigned to memory" and to Phillip Giesen for his Spanish language research. C. William Clewlow, Jr.'s participation in organizing the original exhibit is also acknowledged.

All of the people who have contributed funds are listed elsewhere, and I am indebted to them. Most of them are personal friends of long standing, and I appreciate their trust. Since this book is designed to profit no one but the research program of the UCLA Rock Art Archive, it is a real labor of love.

Most especially, though, the professional skill and personal involvement of my husband, Johannes Van Tilburg, are reflected here. His expertise is invaluable, his encouragement constant.

Ancient Images is a present to all who have participated and a reminder to others of our obligation to cherish the past.

Jo Anne Van Tilburg
Isla de Pascua Chile

Preface

This volume is intended to accompany the National Park Service exhibit of rock art titled "Shamans' Songs: the Rock Art of Western America." It is part of the ongoing effort of the Institute of Archaeology and the Rock Art Archive at UCLA to communicate to the general public some of the important and dramatic aspects of archaeological research. Intended for the general reader and viewer, the more scientific and pedantic aspects of rock art studies have been left to the bibliographic references, while the articles here provide the essential background for an understanding and appreciation of the ancient art so well reproduced in the photographs.

Publication of this catalog has been made possible by a generous grant from the Ahmanson Foundation. The authors and photographers have contributed their work without compensation, and their combined efforts allow us to make available many of the spectacular but little-known creations of ancient artists in the Californias.

The present exhibit is an outgrowth of an earlier one, "Ancient Images on Stone," contributors to which are acknowledged separately. We have not attempted to reproduce all of the photographs used in the two exhibits. Owing to the dynamic nature of the first exhibition, which must be modified to meet local display situations, we present a cross-section of the art with the full understanding that each exhibit will vary in the number and nature of photographs shown. Indeed, some revisions are already being planned for subsequent use of the exhibit in new contexts. Therefore, this is not a one-by-one listing of items on display, but rather a selected set of examples accompanied by sufficient background information to allow appreciation and understanding of the full exhibit.

Rock art is particularly vulnerable to destruction and vandalism, and it is our hope that greater public awareness and appreciation of such sites will help in the preservation of these ancient art works as an important part of our national heritage. Much of this art has endured through centuries and millennia, arousing the wonder and admiration of generations of viewers. The least we can do is avoid further destruction and obliteration of the work of these ancient artists, so that future generations will also be able to experience first-hand the creativity of the past.

Clement W. Meighan
University of California, Los Angeles

The Development of Rock Art Studies

The study of rock art in Europe began late in the nineteenth century with the discovery of paintings and engravings made by prehistoric man in the Paleolithic caves of southern France and northern Spain. These superb pictures, mainly of extinct Ice Age mammals dating from 15,000 or more years ago, caught the imaginations of artists and archaeologists throughout the world. Many books have since been published on the subject.

The existence of prehistoric rock art in North America was first noted in the seventeenth century by English settlers in Massachusetts Colony. On the east bank of the Taunton River is a large rock covered with deeply incised abstract patterns and some human figures. This site, now known as Dighton Rock, was the subject of much controversy among scholars, and the curious markings were attributed to Norsemen, Phoenicians, Scythians, and Portuguese explorers. Today we know they were made by Algonquin Indians.

In 1673, while exploring the Mississippi River, Father Jacques Marquette saw paintings of winged monsters high on a cliff, and he described these in his journal. Lieutenant H. W. Emory, a topographical engineer with the military expedition led by General Stephen Watts Kearney to conquer New Mexico and California in 1846, copied some petroglyphs along the Gila River that were later reproduced in the expedition report. The first person to record California petroglyphs was J. Goldsborough Bruff, who crossed the plains in 1850, en route to the gold fields. In Lassen County he noticed strange designs cut into basaltic rock and copied them into his diary.

Many people must have seen rock paintings and petroglyphs on the long push across the continent by the pioneers, but few made records or even thought much about the old "rock writings," as they were usually described. This neglect came to an end in 1876. That year, Lieutenant Colonel Garrick Mallery was in command of Fort Rice on the upper Missouri. Possessed of an inquiring mind, Mallery became interested in Indian picture writing. The following year he published an article on the Dakota picture calendar. These interesting paintings on buffalo hide were used to keep a yearly chronology through the addition of one new figure each year, symbolizing some important or unusual event that had taken place.

In 1879, Mallery retired from the army and joined the staff of the recently formed Bureau of Ethnology (later the Bureau of American Ethnology). He began an intensive study of Indian pictographic art on any surface, wood, stone, hide or bone. The Fourth Annual Report of the Bureau of Ethnology included a long monograph by Mallery on the subject that would absorb him for the rest of his life: *Pictographs of the North American Indians*. A scant 21 pages were devoted to rock art, but California sites were featured and two pages in full color illustrated the Painted Cave, a Chumash site near Santa Barbara (plate 2).

By 1893, Colonel Mallery had obtained a great deal of new information and that year the Annual Report consisted entirely of his monumental *Picture Writing of*

the American Indians. In this study, about 150 pages are devoted to prehistoric rock art. The book is still considered a valuable reference work as it describes sites that no longer exist.

For more than 30 years after Mallery there was scant interest in the subject of Indian rock art. This hiatus was broken by Julian Steward, a young anthrolopogist at the University of California at Berkeley, who chose rock art for his doctoral thesis. In 1929, the university published this classic study, *Petroglyphs of California and Adjoining States,* which set the pattern for rock art research for many years. He was the first to use the term "pictograph" for rock paintings and "petroglyph" for pecked or carved designs. He established the listing of elements with maps to show their distribution and divided his study area into style zones—procedures still in use today.

Interest in rock art research has been particularly keen in California, where the diversity of the Indian population created many different types of paintings and petroglyphs. Through the centuries Indians following migration routes from the north have entered California. Of the six basic Indian language families, only the Eskimo is missing. All shared a hunting and gathering culture and the craft of basket-making.

The rock art of California is found throughout the state, although there seems to be a preponderance of it in the southern half. Elaborate painted sites exist in the southwestern section, where many examples are found in sandstone caves and on the granite boulders of the Sierra Nevada foothills. Boulder paintings are known in south central Shoshonean territory, rock

shelter paintings in the southern Yuman area. There are also increasing reports of painted sites in the desert.

In the eastern part of California, where there is much volcanic rock, the petroglyph was the favored method of creating rock art. Petroglyphs were carved into the schist and serpentine of the northern and central western areas (Santa Barbara to Clear Lake); in the granite of the Sacramento and High Sierra areas; in volcanic tuff of the far northeast; and in limestone of the far southeast. The cupule or "pit-and-groove" type of petroglyph is found throughout the state. In much of the forested coast, the great inland agricultural valleys, and in many desert regions rock art is only now being sought by researchers. Given the present state of rock art research, it is likely that sites exist in areas that have not as yet been documented.

There are some California pictographs and petroglyphs that can be reliably ascribed to certain tribes, such as the spectacular polychromes of the Chumash in the Santa Barbara region; the bighorn sheep petroglyphs of the Coso Range in Inyo County made by the Western Shoshoni; and the geometric paintings of the Luiseño and Cupeño of Southern California.

The age of prehistoric rock art is a difficult problem, and only in a few instances can we arrive at even an approximate date. An exception is a site in the Santa Monica Mountains where on a panel with typical Chumash paintings, there are four horsemen that must date from the late 1700s when missionary and exploring expeditions were passing through the country. The Chumash polychrome paintings appear to be late, and Mallery pictures elaborate designs near Santa

Barbara which are today almost obliterated through natural erosion. The cupule type of rock art is regarded as early, possibly the first rock art in California, although examples continued to be made until fairly recent times.

Ethnographic evidence lends support to such plausible interpretations of rock art as: clan symbols, important historical events, and shamanistic practices. Shamanism would include hunting magic, astronomy, visions or dream quests, puberty ceremonies, and prayer rocks for individual supplication.

Rock art research has become an ever-growing field of study, with many books and articles now available. Today there are national rock art study organizations which conduct symposia every year in various parts of the country (Canadian Rock Art Research Association in Canada and American Rock Art Research Association in the United States). The field of rock art research has become one in which more and more professionals are becoming involved, but the backbone of the effort is still an avocational one.

The essays in this volume are written and edited by current students of California rock art. Their interest is reflected in the direction of their research and the style of their writing, and the information given here is of a general overview as well as a specific research focus. The style of writing ranges from the informal to the more technical. The photographs represent one of the best ways in which rock art may be recorded, preserved and appreciated. The entire work demonstrates the attraction and wide appeal these fascinating pictures have for all of us.

Campbell Grant
Carpinteria, California

Plate 2
Painted Cave, San Marcos Pass near Santa Barbara, is one of the most outstanding examples of Chumash pictographs. First noted in the papers of the Reverend Stephen Bowers, the site is now the responsibility of the State Parks Department. Photo: Mark Oliver.

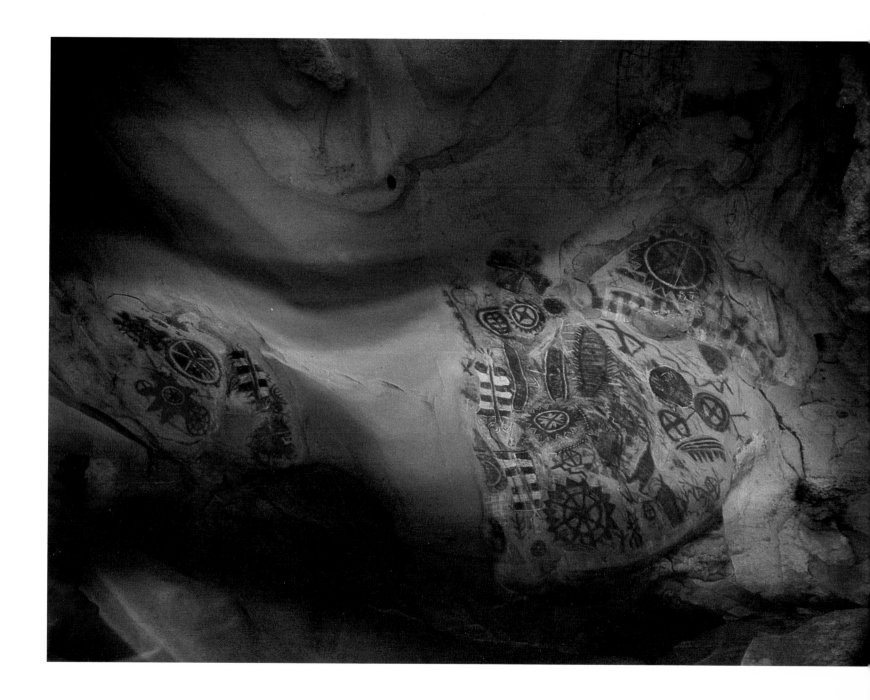

Of Art and Artists: The Rock Art of California

My words are tied in one
With the great mountains.
With the great rocks,
With the great tree,
In one with my body
And my heart.

Yokuts shaman's prayer for good fortune

The Setting

There are those who look at California and see a land too static: too much sun, too little seasonal variety. Their gaze sweeps too quickly over the landscape. Seasonal changes are subtle, colors are soft. The deserts and inland valleys shimmer in pastel hues. The springtime profusion of wildflowers is accented with the spiked candles of the yucca, and even the sunburned summer offers the brilliant red of barberry and manzanita fruit. The sun at the end of the day casts cool shadows, and sudden sheets of lightning and torrents of rain add a melodramatic note to the spring and winter night.

Running streams wash the mountainsides after the winter rains. Densely wooded canyons of laurel and alder are incised deeply into the grey-blue bristle of chaparral cover. An abundant variety of small animals and birds, coyotes, raccoon, and deer make their homes in the hills, and an occasional family of bobcat or a lone mountain lion are not uncommon. The red-tail hawk and night owl rise and fall upon air alternately mountain hot or ocean cool.

California's coastal mountain ranges are generally formed of conglomerate, basalt, and sandstone. Wind and water erosion have cut this rock into formations of strikingly unusual shapes and juxtaposition. Caves, depressions, and shelters result. Even in the summer heat, natural grottoes hold some water. These hospitable places support luxuriant growths of ferns and columbine, and harbor hosts of insects.

In the more northern parts of the state, the landscape can only be described as monumental: trees incredibly tall; steep, salt-sprayed ocean cliffs; fast-flowing rivers. The beauty of the Sierras is legendary. The coastal waters of the Pacific are rich in marine life; abalone and clams are plentiful. Otter and seal are regularly seen off the shores of Malibu and northward. The annual migrations of the California grey whale occasionally bring the great beasts within sight of those standing on the Palisades of Santa Monica. The Channel Islands and Catalina ride the horizon, sometimes temptingly within reach, often deep in mist.

Heavy fog lies on the mountains in winter, and inland temperatures sometimes fall below freezing. The Santa Monica Mountains have been covered, however briefly, in snow, and the floodwaters of many normally placid creeks have claimed lives and damaged property.

California is a place of sharp contrasts and sudden changes; the very ground under one's feet is sometimes unstable. It is a challenging, hospitable, beautiful place. As a setting for experiencing rock art, it is at once background for and an important part of the total impact of each separate work.

The People

It is estimated that humans have lived in North America for 25,000 years or more. California was home to people of seven linguistic families speaking some 120 separate languages. These peoples inhabited virtually all of the distinct ecological areas of California. In general, their material lives were uncomplicated. They were not farmers, but hunters and gatherers. They were mobile within specific territories. Coastal dwellers exploited the richness of the seas, and many were expert at ocean technology.

The record of precontact habitation in California is sometimes sketchy and incomplete. It is read largely through a collection of created objects left behind, strewn through dust and shadow.

Extensive and "official" collecting of California Indian artifacts did not really begin before 1870. By that time, the mission period had exerted its terrible force, the war with Mexico had come and gone, gold had been discovered, and extensive settlement by whites was an accomplished fact. In the period between 1769 and 1890, the aboriginal cultures of California were irrevocably changed or destroyed.

Some tangible remnants of the many and varied Indian peoples survived, however, and these items of beauty and artistic skill tell us about an often eloquent regard for color and form. The ethnographic record indicates a rich and varied intellectual and spiritual life as well.

An ancient dance tradition, for instance, existed among the Hupa, Yarok and Karok tribes of the northern part of the state. Beautifully fashioned obsidian blades were used there in the deerskin dance, and decorated elkhorn purses were used to hold shell money. In central and northern California, shell money was often a part of artistic expression. It was utilized both as decoration and as a symbol of wealth.

The Pomo and Hupa peoples, as well as other tribes including the Chumash, made elaborate and distinguished crowns of carefully matched flicker feather shafts. They fashioned iridescent red woodpecker crowns into headdresses. Earrings and other jewelry enhanced costumes.

The Pomo, Yokuts, and Chumash tribes excelled at basketry. Gambling trays and baskets were of intricate and complex design. Their regard for wealth and conspicuous display was expressed in baskets of textured lightness, created from a well-developed tradition of basketry. Indeed, the greatness of California basketry is widely acknowledged. Pomo feather-embellished baskets were special gifts to friends, an important part of rites of passage ceremonies. Many of these artistic creations were decorated with dangling abalone shell and came equipped with suspension strings. They were hung in trees, left to sway in the bright light.

Arrow and diamond patterns of central California baskets relate to myths and tales for children, and tell us something about the rich oral tradition these people enjoyed. There is some speculation that a relationship between California basketry designs and some rock art motifs might exist.

You must not be in love with what you have, for these things will someday disappear. You are also going to disappear, and so will it be with everything else and everybody else.

The Chumash Naiyait to
his granddaughter Petra

Plate 3
Zuma Ridge in the Santa Monica Mountains, seemingly afloat in early spring fog. These mountains, surrounded but not yet engulfed by the Los Angeles megalopolis, are the setting for several important rock art sites. Though situated in the Santa Monica Mountains National Recreation Area, all archaeological sites in the mountains are somewhat endangered. Photo: David C. Ochsner.

Plate 4
Water was important to Native Californians, and rock art sites were often located in close proximity to springs and streams. This is Sycamore Creek, Santa Monica Mountains, in the springtime. Photo: David C. Ochsner.

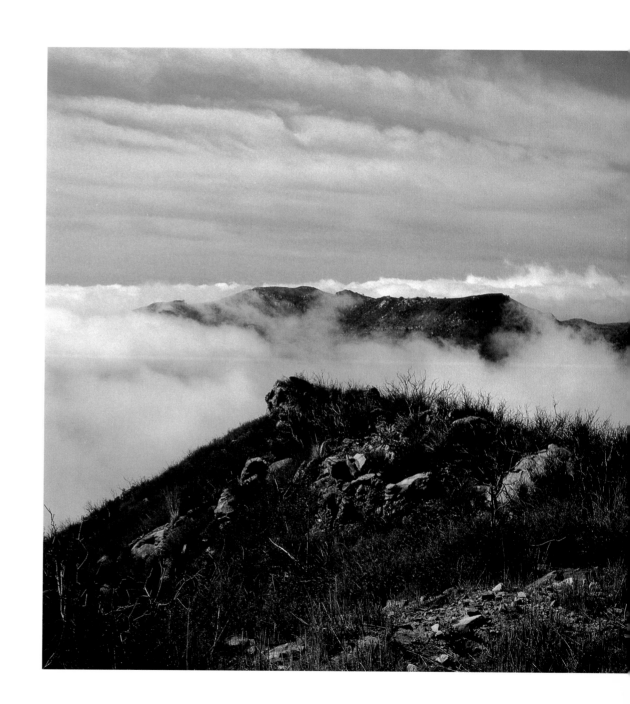

Art gives a special, unique insight into people and cultures. It tells us much more than anything the archaeologist's spade can uncover. It shares with us a cultural heritage of a people expressed through the unique creative abilities of individuals. Among all the artistic treasures left by the early inhabitants of California, surely rock art has an important place.

The Art

"It is indeed a strange art whose roots disappear into the darkness of time and which already in primitive ages was producing works which cause the civilized mind to marvel."

Baudelaire

An appreciation of rock painting and carving casts one far back in time, to the caves of Paleolithic France and Spain. Here, at the world-renowned sites of Lascaux and Altamira, some of the most magnificent cave paintings known to the modern world are to be found. The designs of bison, antelope, horses, and other animals are complex and lifelike. The techniques are simple, the art immediately recognizable as a distinctive and vivid communication link with the past.

Henri Brueil has contributed to the study of rock art a pioneering description of the possible evolution of cave paintings from the Aurignacian period through the Magdalenian. Detailed observation and careful methodology produced a valuable classification of Ice Age art styles, which has been amplified and clarified by later scholars.

According to Breuil, art was first produced during the Aurignacian period (25,000 BC–15,000 BC). Meandering lines were scratched into rock walls, possibly in imitation of bears sharpening their claws and thus producing linear patterns. The artist may merely have followed existing natural patterns in the rock, enhancing the design perceived there. There are many theories as to what might have inspired the first artist's efforts—playfulness, boredom, or projection of images seen in the mind's eye upon rock shapes reminiscent of that image. Whatever the impetus, the result was the beginning of art.

Breuil's analysis of Ice Age art suggests that hand prints were probably the first wall paintings. Images of the human hand may have been first noted by accident: a sweaty and dirt-stained palm upon a rock wall may have struck someone's fancy in some way. Similar images may have been deliberately created by simply dipping the hand in pigment and placing it upon the wall. A more complex technique was utilized when black or red pigment was blown through a hollow reed against a hand placed upon a rock surface, thus leaving a negative print. These human hand prints are generously scattered everywhere rock art exists (plate 6).

Rock art, then, was first dominated by hand prints and finger tracings. As the Aurignacian style developed, both technique and complexity of imagery evolved. Outlines of animals were incised into the rock in profile. Many of these animals were portrayed much larger than life size, and were often enhanced with the application of pigment. Refinement of color technique was left, however, to the early Magdalenian period.

The Magdalenian period (15,000 BC–10,000 BC) produced the graceful and fluid contours of the highest

stage in the development of prehistoric cave painting. Modulated rock contours, subtle color treatment and finer incising techniques produced works of unsurpassed excellence.

Portable rock art, a form of Ice Age sculpture, achieved a high level of artistic expression. Realistic and "abstract" carvings of great diversity were produced on pieces of bone, ivory and stone. These figures, transportable because of their small size and lightness, were exquisitely detailed. The plump little "Venus" figures of the Aurignacian period are probably the best known of this type.

The beauty of Ice Age art may be seen by even the least discerning eye. Animal shapes are identifiable, acceptable and realistic, and the viewer is drawn to them by their familiarity. "Abstract" forms, combined animal-human forms (anthropomorphs) and their baffling relationships to representational animal figures, are often overlooked when Ice Age art is described as "realistic." The more "abstract" the rock art symbol, the harsher the modern judgment tends to be.

What constitutes art? What qualities or components, taken together, add up to artistic expression, as distinct from the mundane, from idle doodles or graffiti? Is beauty really in the eye of the beholder, or can it be defined?

Franz Boas wrote that throughout history, art has risen from two sources, technical pursuits and the expression of emotions and thought. Any composition or activity may have aesthetic value whenever the "technical treatment has attained a certain standard of excellence, when the control of the processes involved is such that certain typical forms are produced." However simple the forms may be, they "may be judged from the point of view of formal perfection." Technical expertise and an intuitive feeling of form defines much of what is known as "primitive" art. Boas' theory of art is based upon a twofold source of artistic effort: form itself, and ideas associated with or transmitted by form.

Boas maintains that nature does not seem to present formal ideals or fixed types for imitation, and that a feeling for form develops through technical expertise. Stability of form thus creates style. Boas would number the women basketmakers of California and the women potters of the Pueblos as artists by this definition.

Form and the creation of styles are essential features of art. When forms convey a meaning, either because they recall past experiences or because they act as symbols, a new element is added to aesthetic communication. There is a direct appeal of the work of art on the one hand, and a specific aesthetic tone created by associated elements, personal or societal, on the other. Art then, in part, is described as forms that are expressions of emotional states or ideas.

In considering style in rock art analysis, Polly Schaafsma (1980:7) states:

Among the major components of style in regard to rock art are the element inventory and the specific figure types making up this inventory. A figure type is the specific form and characteristic mode of expression of any given element. Important in

13

Let us live long in this world.
This is our water.

Yokuts
Shaman's prayer before drinking strange water

Plate 5
Arrowhead Springs, a Chumash pictograph near Santa Barbara, is located at the source of a running stream. Several bedrock mortars are found nearby, suggesting that the site was not far removed from everyday activity. Traces of asphaltum near the top of the painting may have been applied decoration. Photo: William D. Hyder.

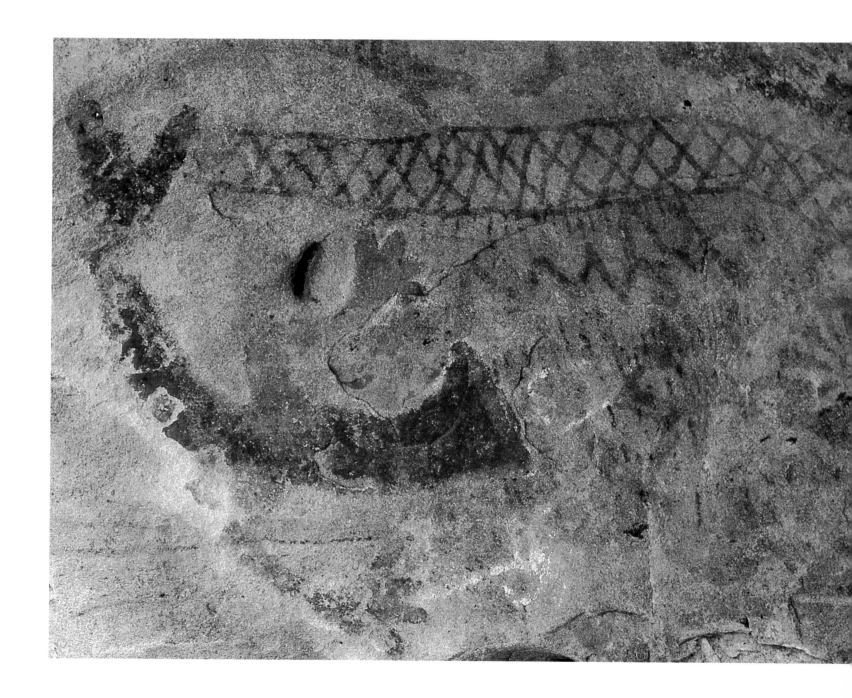

the development of figure types are the major design components and the shapes employed. Second, the forms used and the relationships between the elements of a panel work together to create an overall aesthetic quality of expression that in many instances is an important aspect of style. The various technical means employed in creating designs also contribute to the general sense of style and its aesthetic consideration.

One clear challenge to rock art research is the documentation of all known forms in a given area. Superficial sampling of forms produces inadequate data from which to extrapolate style. Taking Schaafsma's definition as a sound basis upon which to proceed, any analysis of rock art styles would require consideration of "mode of expression and aesthetic quality in defining styles, as well as the secondary but nevertheless significant role of media or technique" (Hedges 1981:5). Simply counting the number of times a given image appears in a given area is incomplete methodology.

To date, research into the classification of rock art forms as styles has been, probably of necessity, somewhat arbitrary. The application of scientific or statistical techniques to rock art design data is only in its very beginning stages. Assignment of individual elements to narrowly defined stylistic groups is not, as yet, a clear-cut process. Indeed, there is some doubt as to the possibility of totally clear distinctions. Hedges states, for example, that it is "important to note that with rock art, we are dealing with a subjective product of the human mind which must be studied in a subjective manner, but not necessarily to the exclusion of other approaches (1981)."

There is a fairly extensive amount of literature, beginning with Boas, which is devoted to the nature of "primitive" art. Little is specifically written about rock art. It seems clear, however, that the elements of form, standardized excellence, and technical expertise exist in rock art. Shape, color, texture, and symbolism are also present.

The task of interpreting the symbolism represented in rock art is complex and often impossible, but is not essential to the appreciation of the material as art. Interpretation of rock art symbols may be attempted on several levels:
1. The source of the image (what is it a picture of?).
2. The context (in what ritual or other context does it occur?).
3. The meaning (what does it mean?).
4. The function (how does it function in the culture or ritual?).

An example of this multilevel interpretive possibility might be the concentric circle or "sunburst" symbol found at certain Chumash rock art sites. This symbol may be a visionary phosphene image (*source*) in the *context* of a winter solstice ritual with the ascribed *meaning* of a "winter solstice sun." It may *function* to mark the position of a sunlight dagger, signaling the time for a particular ceremonial event. The general associations of the "sunburst" might therefore be astronomy and world renewal. The implications of such a thorough examination of possible meaning in rock art are well discussed by Reichel-Dolmatoff.

The search for themes running through the imagery is a major research goal, and mythology plays an important role in this type of investigation. Elements at a given site that might once have been thought to be

isolated or merely juxtaposed without any thematic link have been occasionally shown to have some possible conceptual connection. Individual elements are then rightly regarded as part of a total composition (see Lee, this volume).

In examining the meaning of rock art, consideration should be given to the existence of an objective desire to achieve a form or image of pleasing visual impact, of aesthetic expressiveness. In other words, analysis of rock art, from whatever period, must go beyond conventional wisdom or aesthetic dogmatism and be creative in its own right.

The human psyche, as we realize more clearly with every advance of mental science, is the product of a delicate adjustment of sensation and thought. Humans are called rational because they are able to form concepts and relate new experiences to universal abstractions. There seem to be two distinct modes of intelligence. The Cartesian (as described by Descartes) divorces reasoning from the sensuous dependence on things and constructs a structure of rational and ideal thought. This intelligence observes nature, classifies observations, and deduces logically to build that edifice called science. Aesthetic intelligence, in contrast, maintains contact with the sensuous world at every stage of reasoning. The sensuous appreciation of color, texture, and formal relationships is organized in order to intensify the pleasure of the senses, not necessarily to increase the knowledge of the mind. The ability to assimilate sensuous impressions from the natural world of universal experience and then combine them in significant relationships is what constitutes an artistic sensibility. It is this faculty that contemporary hu-

mans use less and less. The increasing dependency on reason divorced from natural rhythms and universal truths creates what Hannah Arendt calls "earth alienation," that hallmark of modern science.

The expression of feelings or ideas in communicable form demands infinite subtleties as well as specific symbols. Our society has developed language and logic to such a point of refinement that we tend to ignore, simplify, or disparage the primary, nondiscursive language of symbols. What we glibly describe as "abstract" might better be explained as "idealized." Georgia O'Keeffe, one of the world's most expert artists in her use of symbols, describes one of her works, "Green-Grey Abstraction," in this way:

There are people who have made me see shapes—and others I thought of a great deal, even people I have loved, who make me see nothing. I have painted portraits that to me are almost photographic. I remember hesitating to show the paintings, they looked so real to me. But they have passed into the world as abstractions, no one seeing what they are.

The understanding of rock art symbology, indeed of any artistic language, requires an acuteness of perception and sensation. Appreciation of the instinctual and emotional components of the creative personality can be coupled with receptivity to the setting. This sensuous impression can then be integrated into an intellectual framework composed of historic, ethnographic and archaeological information.

An example of research concerns that goes beyond mere counting of elements is the consideration of the rock upon which the art was done. Rock as the logical and available "canvas" upon which the ancient artists

Hands

Inside a cave in a narrow canyon near Tassajara
The vault of rock is painted with hands,
A multitude of hands in the twilight, a cloud of men's
 palms, no more,
No other picture. There's no one to say
Whether the brown shy quiet people who are dead intended
Religion or magic, or made their tracings
In the idleness of art; but over the division of years these
 careful
Signs-manual are now like a sealed message
Saying; "Look: we also are human; we had hands, not
 paws. All hail
You people with the cleverer hands, our supplanters
In the beautiful country; enjoy her a season, her beauty,
 and come down
And be supplanted; for you also are human."

Robinson Jeffers

Plate 6
Hundreds of stark white human hand prints contrast with the smoke blackened walls of grotto-sized shelters in the Ventana Wilderness. Elements drawn with chunks of pigment serve to further embellish the rock surface. Photo: Kathleen Conti.

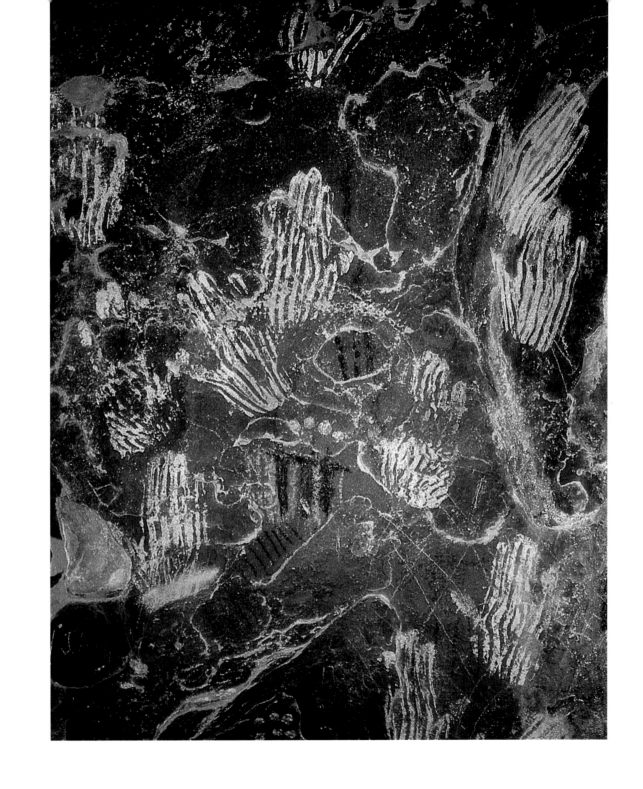

worked is interesting in and of itself. Raoul-Jean Moulin states that "Rock is never neutral; as the artist works it, he uses its collaboration. He accepts it as it is, hard or soft, smooth or rough, taking advantage of its defects as well as its help, causing its expressive possibilities to work for him." He goes further to say that the transformation of rock has an effect upon the artist as well. "His creative impulses increase as he discovers, re-invents, the natural shapes." It should be noted here that Moulin, as well as so many other researchers into the archaeological past, refers to shamans/artists as men. This is not a documented fact in all cultures.

Because of the beauty and impact upon the public of the cave paintings of Spain and France, Europe has long been the focus of important research in rock art. Other areas of the world also have magnificent treasures of rock art to explore, however, and serious research is being done in several places. Africa, for example, has thousands of sites, many estimated to be at least 7,000 years old. The paintings of the Tassili are lithe and lovely. The continent of Australia possesses the exciting and possibly unique distinction of being a "living laboratory" of rock art, where some paintings are still being made today. The rock art of China is as yet unknown to the West, and parts of South America are rich in rock art sites. The complexity of rock art found in the various geographical areas of North America is vast.

Originally, humans coming to the New World crossed the Bering Strait with Magdalenian-style tools. Did a Magdalenian style of art accompany them as well? Why didn't North Americans develop the fine distinctions and technical expertise of European rock artists?

Campbell Grant has speculated (1967:40–42) that the highly developed painting tradition of Paleolithic Europe might have been the result of sparse populations heavily concentrated around the huge caves used as communal shelters during the glacial period. Over the enforced leisure of this extended period, an artistic "school" was given time to evolve and flourish. Grant further thinks that the original creative spark might have been struck by the skill of a single individual, taken up and emulated by others. In the history of art, one individual's influence on his/her contemporaries is well documented.

North American tribes, in contrast, were hunters and gatherers, roamers over vast territories, never long in one place. Under such conditions, the development of a highly refined rock art tradition seems less likely to Grant. Rock art as part of a larger artistic tradition, such as in the Pueblo culture of the Southwest, developed along different evolutionary lines.

"Art for art's sake" was not, according to Grant, the main motivation of Indian artists. Religion and special ceremonial purposes are the important factors that moved Native North Americans to produce rock art. He does, however, acknowledge the difference in creative ability among individuals, as well as the effect on style of a forcefully imaginative artist. The phrase "art for art's sake" carries, of course, numerous connotations which are philosophically Western, scientific, and rational.

When considering the rock art of North America, it is necessary to examine what Ralph T. Coe defines as "indianness." In his introduction to *Sacred Circles*, Coe

attempts to define that element in Native American art, past and present, and to begin to interpret the qualities of emotionalism and meaning that Boas finds so essential to "real" art. Coe explores a unique and interwoven approach to nature and its relationship to man, to myth, to time and space, and to an unseen "presence" basic to North American Indian cultures. He notes that qualities of restraint, serenity, composure, sobriety, and quietude are expressed in a wide variety of Indian art. There is, for Coe, a harmonious aesthetic form and content found in all Indian art, though he never examines rock art specifically. "The Indian artist refers continually to the springs from which his art first emerged, never turning from that source. His art expresses for those who lack belief in myths something of the quality of myth." Design and nature are equated in a particular way, "especially in those areas to which Indian awareness is almost exclusively addressed: to the land, mythology based upon natural causes, and the spatiality of the continent itself."

There seems to have been no word for art, as an independent concept, in most Native American tongues. Creating and decorating objects, while complicated activities, were admirably direct processes. The expression of harmony and beauty in the resultant design seems a general result of the total cultural context, and Coe expresses this most clearly:

If the relationship of one thing to another in terms of exact proportional measurement is unclear in Indian art, the Indian traditional assertion of attunement with his creator and his environment—one interdependent upon the other—is met with at every turn. It is asserted by what, for lack of a more specific term, we may call "presence." It is a term not unlike the Indian word for power, "medicine." Here it becomes an artistic counterpart. The presence of Indian art is contained in its ability to project psychic intent or idea through design impact. That process replaces scale. Indians knew much about strongly optical design devices and symbolic equivalents without the settlers' teaching.

Art and the primal impulse to communicate through art is one of the most significant tools available to us in our quest to understand, to relate the past to the present. In California, the gallery of rock art left behind upon the very substance of nature is a major insight into the cultures that inhabited this land before we did. It is a distinctive and diversified tradition of art which is, at the same time, an integral part of the worldwide collection of rock art.

Some of the most profuse, spectacular, and varied paintings found in the state are located in Santa Barbara, Ventura, and San Luis Obispo counties. This land, once inhabited by the Chumash, is now some of the most sought-after real estate in Southern California.

Research by Campbell Grant (1965:85) indicates that all of the colors that composed the ancient artist's palette were—not surprisingly—natural pigments, products of the earth. Shades of yellow, white, and black were common. Red paint, found at almost all known pictograph sites, is the ochre known from the earliest cave paintings of France and Spain. From Paleolithic graves where ochre was found coloring burial objects and skeleton alike, to current Australian aboriginal funerary practices, hematite is utilitarian as well as mostly symbolic.

While pictographs are found in some of their most

21

it is a time
of visions
it is a time
of painting
no more do we
hide our dreams
we wear them
on our shirts
round our necks
they make music
in our hair

Karoniaktatie
1973

Plate 7
This pictograph, found near Porterville, is attributed to the Yokuts, a tribe whose territory was bounded by the Chumash. Yokuts paintings are stylistically different from the Chumash in several ways, and both tribes are represented at Painted Rock, Carrizo Plain. Photo: William D. Hyder.

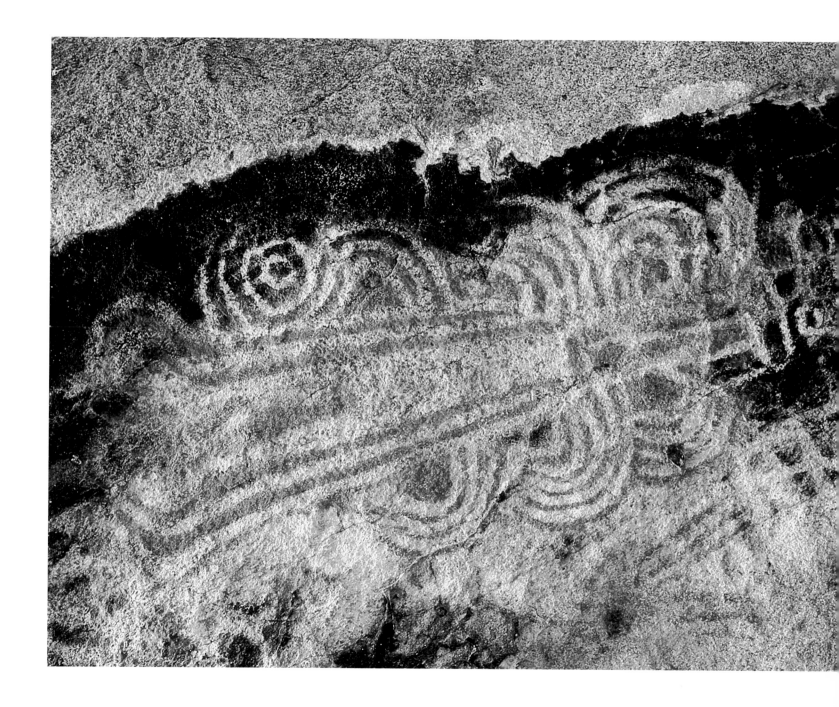

intriguing and colorful forms in the coastal mountain territory of the Chumash, other types of designs are noted in Southern California. In the lands of the Cahuilla and the Luiseño, it is known that paintings in red ochre were done as part of girls' adolescence rites. It would be a mistake to assume that all rock art in this area was done as part of this ritualistic observance. Kumeyaay rock paintings, at the southern margin of the state, are frequently polychrome. Clearly, more research is necessary before definite conclusions can be reached.

Petroglyphs, as distinct from pictographs, were created by pecking, incising, or abrading a stone surface so as to remove the outer layer or patina, thus leaving a mark. Carved into the living rock, petroglyphs are by their very nature more durable than pictographs. Petroglyph sites are commonly found in association with water, often along trails, and in the high desert. The great stone gallery of the Coso Range of California contains an abundance of elaborate and distinctive carvings (plates 15, 16).

Geoglyphs, once called intaglios, are another, less common form of rock art found in California. These huge and impressive figures were created by raking or removing surface gravel to reveal the lighter subsurface (plates 18, 19). Rock alignments, as distinct from geoglyphs, were made by stacking pebbles and cobbles to make cairns, or by aligning cobbles in long rows or designs.

The continued research and documentation of rock art sites is completely dependent upon the success of preservation efforts. Conversely, there can be no preserva-

tion without documentation. Knowledge gained through the study of rock art is important to all segments of society, especially the Native American. Dislocation of aboriginal cultures in California, first by the Spanish and then by the American onslaught, resulted in a situation of almost total assimilation. Folklife and folk mores were lost to most of the descendants of the first inhabitants. Scholarship today can serve a significant social purpose: it can give back some of what was so violently taken away.

But in the end, in our attempt to learn about rock art— to record, photograph, catalog, and decipher—we may learn little of "scientific" value. The insights gained may be ephemeral. Even so, the attempt is worthwhile. The qualities of intellect and emotion expressed in the art are enriching, in and of themselves.

In his book *Stones of Silence*, George Schlater writes, "Science still remains a dream, for it takes us no more than a few faltering steps toward understanding; graphs and charts create little more than an illusion of knowledge. There is no ultimate knowing. Beyond the facts, beyond science, is a domain of cloud, the universe of the mind, ever expanding as the universe itself."

Jo Anne Van Tilburg
Malibu, California

A Native American's View of Rock Art

The artistic forms and concepts presented in rock art are accepted by Native Americans on a philosophical, religious, and secular basis. When understood and related to from this perspective, the spiritual aspects as well as the beauty and imagery give rock art and the symbolism of rock art an important validity as an ongoing art form.

Rock art is, in many cases, looked at as a "dated" and "older" kind of artistic expression by art critics and the general public because there are few known contemporary or recent historical activities of this type in North American art. The Native American traditionalists, however, are aware of the meanings of the stories, legends, and truths found in oral tradition. In the practice of ceremony, those ideas and concepts are given expression. As these truths are given artistic form, they become articulated in forms and designs similar to and sometimes the same as those found in rock art paintings or petroglyphs.

Rock art and traditional art are interested in presenting the world as it is. That view is not always linear in concept, and in many cases will appear to be more subjective than objective. One way to view the art is to remember it is speaking of a traditional view of reality and how it works. Therefore, it is not strange to see animal and bird forms in combination with the human form. Sometimes it helps to explain the abilities of those with psychic, healing, medicine, or shamanistic gifts by using metaphysical archetypes. For example, a person who can project his/her mind to gain information from a distance is better understood, or easier to understand, if spoken of or drawn as a human-bird being. Then the concept of projection becomes more "common" or rationalized and acceptable. Modern contemporary society is only now beginning to realize the extent to which traditional people practiced their psychic abilities. They could do so because their psychic frame of reference was founded on an understanding of the principles of natural law which included a wholistic vision of earth and life.

The importance of rock art forms, designs, colors, and concepts reinforces and continues to emphasize the validity of the traditional way. These elements basic to all art allow the Native American artist to visualize concepts in his/her tribal traditions; their reference to the spirit of rock art, along with traditional philosophy, expresses the vitality of the emerging contemporary art.

If contemporary Native American art and artists seem to mimic or replicate rock art forms, it is incidental to the importance of the function that symbols are meant to convey. Art helps to create order; elements of this order are some concerns that continue to identify mankind's relationship to the bioethical responsibility of the way we choose to live, the way we relate our lives to the idea that there is a universal connection in all things. This connection is philosophical, the idea of oneness with the environment and an interaction with the world, not dominance over it. The sacred circle exemplifies oneness. This is the harmony and balance of the individual with the world and space around him.

Another element found in rock art is the distinction of regional flavor, in the emphasis on certain animals,

25

insects, fish, or fowl found in specific regions. Too much research importance has been and is placed on analyzing regional styles. What the Native American is primarily relating to is the concept of the wholistic living earth. Inanimate things have so-called human qualities of life and spirit, but these are not bestowed on them by human beings. It is in their nature. We sometimes refer to the qualities of spirit in inanimate things in our attempt to grasp a better understanding of the idea that all things have life, and that all things are part of one another. There is a sacred spiritual reality that the symbols represent, an understanding that it is proper and just that we all belong in this space at this time and place. Different animals in different environments and territorial areas, all part of nature, are represented; the intent of the art and the use of the animals and beings reflect a sharing and belonging, a connection to the things around us, a unitive vision. Art that reflects ceremonial and religious principles will be similar to the "old" forms. Some of these old forms are cross, circular, dot, and line forms (plate 2) as well as animals and human beings which represent aspects of religious thought and relevance. They express the traditional concern that some things worth maintaining and continuing do exist and have meaning for each succeeding generation.

The emphasis on monumental art or events, or the idea that "bigger is better," does a great disservice to the appreciation of rock art as well as of other traditional art forms. Some of the symbols used by artists today are the very same ones found at rock art sites. As I relate to the meaning of these symbols, I am reminded of their grandeur by the concepts they represent, not by their size. Many of the rock art paintings and petroglyphs are not large, yet they carry the function, meaning, and concretization of a vision and the relationship and connection of that vision to us through the use of specific symbols. One example is the depiction of the universe by the circle and the four directions by a cross inside that circle. The addition of color for the directions enlarges that image to encompass a larger vision.

Society has acknowledged and given individual artists the right of individual expression; so much of the visualization and expression is personal and sometimes hard to share without explanation. Traditional art, on the contrary, was of the community and understood by a greater proportion of society. Nowadays, we have what were once vitally understood symbols still functioning as those symbols, and a greater number of people having to be told what those universal symbols or concepts represent. It becomes very important to continue to research and keep an open appreciation of the different levels of communication. It is no wonder that visionary art seems so exclusive, when the basic symbolic knowledge is forgotten. An artist knows intuitively, or on a conscious level, that art work has "to make itself known" in order to function. (For people to comprehend abstract concepts or unknown spirits, they require the assistance of one who can mediate with the spiritual realm and who can bring information used to "give" a name or "make known to the people" the identity of the spirit.) We would say that in order for a traditionalist to translate the concept of "spirit," he/she would have to find a form that stood for spirit or gave a name that was the idea of a spirit. This in no way should limit the essence of the particular spirit that the art forms and "naming" represent. As rock art has been analyzed, we have begun to understand that it is a combination of vision, myth, visualization, and an explanation of humanity to the universe around them.

In understanding Native American art and its concepts and ideas of organizing reality—and thus helping to maintain the harmony and balance of the earth—we realize that life is difficult but not without beauty or joy. Traditional activities and arts are involvements having a primary concern and purpose: participation in meaningful acts and in making "meaningful art." Concern for harmony and balance reflects the belief that interdependence of man and nature affects the well-being of the living earth and its inhabitants. Lack of respect for this interdependence produces disharmony. If our lives and actions are not in tune with the universe, the earth will suffer a sickness of pollution and imbalance that eventually will destroy the fertility of the earth, the air we breathe, and the purity of water. Rock art symbols speak of this relationship. The traditional way of life also exemplifies a conscious effort to preserve life.

When we begin to understand the meaning of the symbols, it becomes clear that traditional art is complex and deals with a relationship that is trying to make sense of the natural law of reality and how best to maintain a living earth. Ceremonies, songs, and prayer are manifestations of the Native Americans' concern with understanding this purpose of life.

Native Americans are not interested in the preservation of rock art or other sites for the mere sake of collecting artifacts or having places of interest to visit. We are concerned with the larger sense of meaning inherent in those places used by the people who have gone before us. We do not believe in the desecration of any rock art site. We desire the safekeeping of all sacred sites. The classification of one site as more meaningful than others, from whatever point of view, should not be a determinator of preservation. They are all worthy of protection. We know the elements of weather and time take their toll on these places. There is a general acceptance that this art, exposed as it is to nature, will eventually be lost through weathering. This seemingly fatalistic attitude is an acceptance of time and change, which is balanced by the fact that it is still possible for Native American artists to actively pursue artistic expression using rock as a medium. This attitude of acceptance also allows an artist to use concepts found on rock art for contemporary art work. It is important to remember that the subjective realities and unitive visions depicted in rock art are still being used in the ceremonies and dances of the Native Americans. The actual use of the philosophical basis of rock art is in fact its connection to understanding its vitality and validity.

One of the most fundamental commitments of the Native American to rock art and rocks in particular is the understanding of their power and ability to remind us of our vulnerability as well as our need for counsel, and patience when thinking about our place on earth. Because of the connection implied in the subject matter, it is important that the Native American artist and traditionalist continue to believe and practice that to which rock art seems to be directing our attention: harmony, balance, serenity, and spiritual unity with nature. As an art form, rock art is aesthetically some of the finest work ever done. It continues to fascinate and relate to contemporary times because philosophically it gives us a vision of a living earth balanced with both the spiritual and physical in harmony.

Frank LaPena
Sacramento, California

27

When Susuna ate the sun,
it caused an eclipse.
"Please, please, Susuna, Susuna,
Please, please, oh don't devour our Sun."

Beatrice Wilcox
Tule River

Plate 8
Coyote was a character important in the mythologies of numerous California peoples. This Tule River Indian Reservation site possibly depicts a well-known tale about Coyote eating the sun and causing an eclipse. Photo: William D. Hyder.

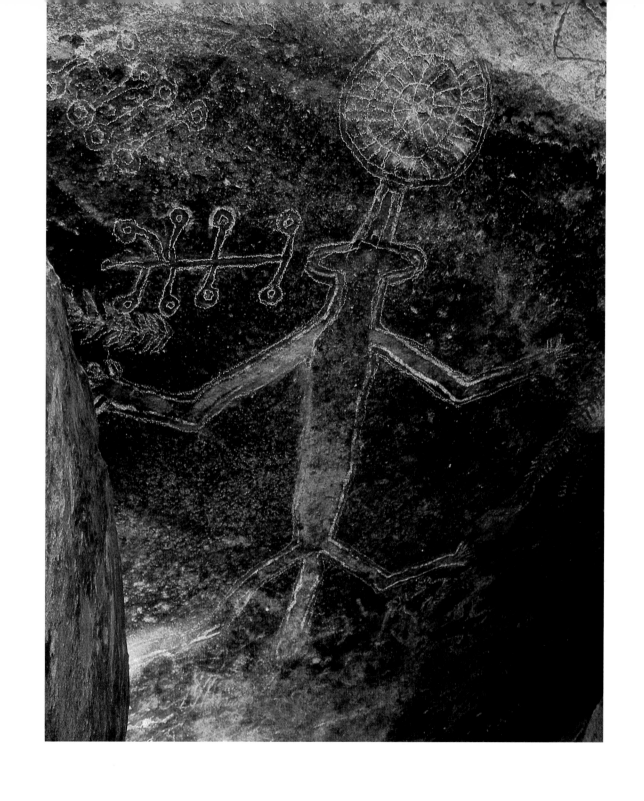

The Art of the Chumash

Chumash rock art sites are special places. Found in areas of great natural beauty, they often have a sweeping vista of sea or rugged mountains, or they may be secluded in dense groves of trees near springs and creeks. The rocks themselves, sculpted by wind and water, frequently have unusual shapes. These places have a magical quality—a quality rarely transmitted in a photograph. Sitting quietly in a painted cave shelter, watching as a lonely hawk soars overhead, it is possible to feel the power and mystery associated with these sites. Here, people dreamed and prayed and sang to the spirits of earth and sky. Their shadows still inhabit the land.

The people we call the Chumash occupied an area stretching from a point north of Cayucos southward to Malibu. Their territory extended inland to the now-arid Carrizo Plain, and continued south and east to Mount Piños, which they believed to be the spiritual center of their universe. The Chumash language had at least six major linguistic divisions. They were semi-sedentary, with the bulk of the population clustered along the shores of the Pacific Ocean. Inland settlements were not large, and many were only occupied seasonally.

Because of the crushing impact of Spanish occupation, much of the culture of the Chumash is lost to history. The ethnographies available to us were gathered fairly late in time (early 1900s) from those who were remembering stories told to them by their elders. While it is

likely that some bias or misunderstanding has crept into their narratives, they are really all we have, except for early Spanish journals and the archaeological evidence. The rock art left behind by these remarkable people is a significant part of that archaeological evidence.

The Spanish were the first Europeans to reach Chumash territory. Most of them spoke of the culture they found there in glowing terms. They described the people as agile, alert, ingenious, and friendly, and the women as exceptionally pretty. Like other California tribes, the Chumash painted their faces and bodies in distinctive patterns which identified the community from which they came. They wore elaborate bead necklaces and other ornaments, and lived in communities of thatched, dome-shaped houses. Their beau-

tifully fashioned and embellished artifacts caused much comment among the Spanish; the finely woven and decorated baskets dazzled them. Society was stratified, with an aristocracy based on wealth, the medium of exchange being shell money. Craft specialization was practiced. They had elaborate rituals and beliefs which included shamanistic practices, the concept of a creator-god, magic beliefs, rites of initiation into adulthood, and mourning rites for the dead—whom they buried with ceremony and paraphernalia. The Chumash had a higher development sociopolitically, materially, technologically, and economically than their neighbors. Possibly one of their most outstanding achievements was their remarkable ocean-going plank canoe.

The Chumash produced a wide range of artifacts from the abundant natural resources in their territory. They utilized stone, wood, shell, horn, and bone. Many of their outstanding artifacts were carved from soapstone (steatite), the main source of which was Catalina Island. Their artifacts frequently were embellished with incised or painted designs and shell inlay.

Pigment was important, both in everyday and ceremonial life. Nearly everything was painted: clothing, canoes, bodies, burial poles. Red was a favorite color and was obtained from hematite (red ochre) or limonite (yellow ochre) that was burned, thus changing the color to red. White came from diatomaceous earth. Black may have been obtained from graphite, charcoal, or hydrous manganese oxide. Yellow was rarely seen in the rock paintings. Blue-green—a rarity—may have

been from fuchsite (a form of muscovite) or perhaps it was obtained from the missions.

The pigment was ground to a powder and then mixed with water or a binder of some sort. The Yokuts used the oil of the chilicothe seed or milkweed juice for a binder; in mission times, cactus juice was used. Other binders may have been egg, animal fat, or urine.

Like other Indians of the Americas, the Chumash believed in the importance of a personal spirit helper, without which one could never succeed in any endeavor. Thus, every individual sought a power connection, and shamans sought multiple dream helpers. A helper could be acquired in several ways, but the most usual method was by ingestion of the dangerous narcotic plant, *Datura inoxia*. The *Datura* drinker could

see the spirits of the dead, and might speak with them. He/she could see supernatural creatures and could locate lost or stolen articles. The visions compressed time and space so distant places and events, the past and the future, could be seen. The most coveted vision was that of the dream helper, which was usually an animal spirit offering life-long protection and guidance. The charming carved soapstone effigies found in archaeological contexts may represent various talismans or dream helpers. Some of these carvings appear to represent whales, or birds such as pelicans and cormorants. Perhaps these were dream helpers of fishermen, carried about and called upon in time of danger or need.

Shamans played an essential part in the defense of the psychic integrity of the Chumash community. Because there was little separation between daily and religious life, the universe was believed to be filled with vast sources of power which humans could manipulate in varying degrees. Thus with the proper power and ritual, shamans could exercise control over physical and psychological surroundings. They combatted demons and disease, and other shamans. They cured sickness, directed communal sacrifices, controlled weather, and escorted the dead to other worlds. They could see spirits, leave their bodies at will and travel across space or transform themselves into other creatures. Shamans spiritualized the world of the dead and enriched it with forms and figures; thus the terrifying world of death assumed shape and became familiar and acceptable.

As a creative artist, the shaman played (and in many cultures still plays) a significant role. Among many North American peoples, creativity is interpreted as a personal gift from the spirits—a talent derived from mystic, visionary experiences and a form of divine inspiration. Rock art is directly related to shamanistic practices. Symbols were painted in an attempt to gain some measure of control over threatening forces or poorly understood phenomena, to safeguard the balance of power in the universe and the continued prosperity of the individual and the group. Thus, the art can be considered a religious expression made in an effort to propitiate the supernatural.

There is some ethnographic evidence from the Chumash area that deals with the potency of rock paintings:

. . . Another method of avoiding a storm was to undertake a rock painting . . . and . . . a long time ago a great famine was created by an astrologer who painted several figures on stone of men and women who were bleeding from the mouth and falling down. This "evil" astrologer took the stone and went into the hills to expose it to the sun. Prayers for sickness were then made, and his efforts were rewarded. No rain came for the next five years, and many people died from hunger. Fortunately for the people, a group of sorcerers found out about the painting. They saved the people from death by tossing the stone into a body of water. This remedy apparently worked, for it soon began to rain (Hudson and Underhay 1978:36).

The Yokuts Indians, whose territory adjoined that of the Chumash, believed paintings to have supernatural power and thought that the shamans painted "spirits" they had seen in dreams. The Kawaiisu thought pictographs were done by the "Rock Baby" and to touch a painting would cause a disaster.

According to Hudson and Underhay (1978:147), Chumash paintings may have been made by shamans

> ... as part of a vision quest; it is likely that some of the more elaborate depictions contain astronomical motifs or subjects, particularly in view of the importance attributed to the heavens by these cult priests and shamans. Some paintings were created because the very process of depicting certain symbols activated supernatural power. ...

The way people view their cosmos affects the structure of their life and how they relate to the world. Such concepts are reflected in art. For this reason, the art of each culture possesses a particular style by which it can be identified and which sets it apart. The rock art of the Chumash has many unique qualities, different from the art of other tribal groups. It often consists of "abstract," nonobjective symbols (see Hedges, this volume). One searches in vain for the anthropomorphic figure with bows and arrows, mountain sheep or deer that occur in the rock art of other areas of California and the Southwest. Chumash art appears to have gone one step further into the cerebral, mystical reaches of the mind.

Chumash art has been called the "Santa Barbara Painted Style." It has certain unifying characteristics. The most frequently noted element is a sun, or mandala, form which appears in many variations (plate 11). Other common designs are the "aquatic" motif (a straight or curved shape with bifurcated ends and a fin-like projection) (plate 5), and many bug-like or lizard figures (plate 21). Nearly all Chumash designs are bilaterally symmetrical. The paintings are usually small in scale and are often made with great delicacy and meticulous detail. Some designs appear free-floating in space, in no relationship to other elements. Discerning patterns or composition is difficult. The majority of the paintings are in red, but it is not uncommon for paintings to also include black and white. Many designs are formed by, or embellished with, white dots.

It appears that ritual activities involving rock painting occurred at two types of locations. One involved group ceremonials, with the community probably participating as spectators. These "public" sites served to link man to the sacred and mythic past. Ceremonials here maintained group solidarity and forged bonds with the supernatural. Sites believed to be in this category have

prominent painted panels that can be viewed by a group. The art appears to represent myths and oral traditions. Painted Rock on the Carrizo Plain is one excellent example of such a "public" site. Others, also in the Carrizo, are SLO-336 and SLO-104. In the Sierra Madre Ridge area, a possible group ceremonial site is SBa-501. Other sites, more personal and secret, are in limited spaces such as crevices or caves, and are usually so small that they accommodate only one person. These may have related to healing, or private rituals such as individual acquisition of power. As private ritual sites, they would be closed to public view and would be considered places of great power.

In an effort to understand the designs of the Chumash, we search for clues in the mythology and ethnology. We have had more luck with the mythology, as some Chumash rock art designs appear to be individual expressions of mythological themes or characters.

In Chumash myths, the timeless past is divided by a major event: a mythical flood which covered the earth and brought about the transformation of the First People into the present animals and plants. The myths tell of the First People and their adventures with supernatural beings, monsters, and one another. One of the most important of the First People is Coyote, the trickster. Coyote had many adventures with Lizard, Turtle, Hawk, Centipede, etc. Everytime Coyote saw a pretty girl he said *tsu-tsu,* which meant sweet kiss. He said it so much that it caused his snout to grow, and that is why Coyote has such a long nose. Another myth tells about Coyote and Lizard involved in a discussion of

how the present humans were to be made. After a heated argument, Coyote convinced everyone that, as he clearly had the best hands, man should have hands like his. Just as he was to stamp his paw print down on a smooth white rock, Lizard, who was standing quietly behind him, suddenly reached out and pressed in *his* handprint first. Coyote was furious, but what could he do? If Lizard had not done this, people today would have hands like Coyote. The famous Painted Rock in the Carrizo Plain (a "public" site) has remarkable paintings of Coyote with his paw prominently displayed. One large depiction of Coyote has a superimposed Lizard.

The ethnographies have enabled us to identify a particular site that was called the House of the Sun. A cave was described with animals "turned to stone" and a big painting of a sun in the cave. Following the description of the physical properties of the cave, we can connect this site with a sacred shrine associated with Chumash rituals.

Our knowledge of Chumash myths is limited, as are the ethnographic data. What is available represents but a sampling of the rich, complex mythological concepts and beliefs of the Chumash.

In Chumash art, one thing stands out clearly: although the paintings are a little different at each site, there appears to be a unity of style and intention. And, there is a correlation between some of the rock art and the designs placed on portable artifacts. Many of these objects—which range from elaborately decorated shell beads and pendants to small sculptural pieces—have designs added to them. These are made in several ways: carved, drilled pits, or punctates; overlaid (such as with shell beads attached with asphaltum); or painted. Many represent enormous expenditures of time, and surely were status items of great value. These symbols had magical significance and transmitted messages reminding the people of basic behavioral norms and mythological concepts. The rock paintings probably were responses to crisis situations when the world was seen as being out of balance (such as earthquakes, an eclipse, etc.). Shamans attempted to manipulate events and bring order and structure to everyday life by the application of sacred designs.

It is speculated that many of the paintings were responses to the crisis created by the arrival of the Spanish. The Chumash were forcibly removed from a free way of life. Herded into the missions, they were made to labor, and were under great pressure to accept Christianity and deny their previous beliefs. Exposed to diseases for which they had no immunity, their numbers rapidly diminished. They did rebel once. It was the only successful revolt in the entire mission system, but freedom was short-lived. They were hunted down and (except for a few who slipped away to join other tribes) returned to the missions where they continued to die from disease, hunger, and overwork.

The rock art left behind by the Chumash is their legacy. The remaining precious fragments of designs offer us bits and pieces of the rich cosmic visions, myths, and dreams of the people that were the Chumash. It is an enrichment of all our lives, including present-day descendants of this creative people. Chumash rock art represents an act of faith and a reminder of those who have gone before.

Georgia Lee
Santa Barbara, California

As the sun rose above the eastern horizon
the Chumash Bear Dancer pointed his hand-held staff
at it, and sang:
Darkness goes blind like a blind man.
Then light bumps into it, and
Light will last forever.

Fernando Librado

Plate 9
Orion and Sirius rising in the winter solstice sky. The presence of Orion in the early evening sky was regarded by many ancient peoples as an event of significance. Photo: Tom Hoskinson.

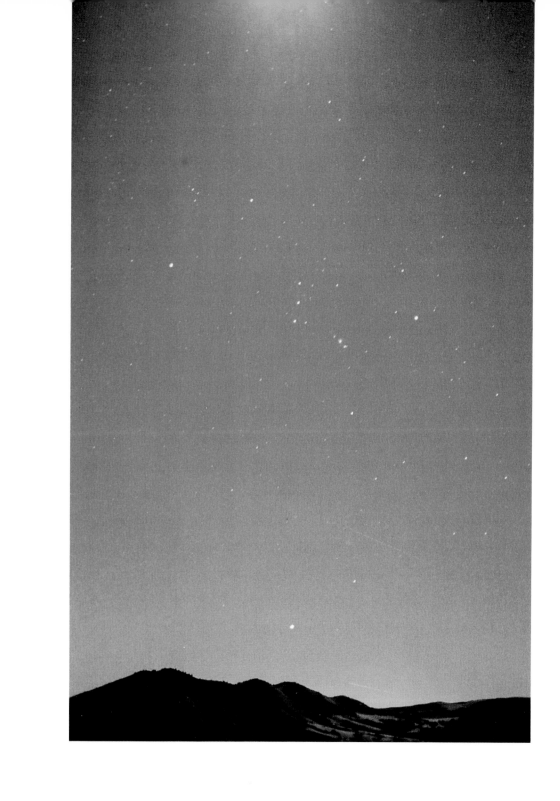

Emblems of the Sky

Images that possibly originate in the sky show up in California Indian rock art. They are important because interpretation of their symbolism allows us to enter the belief system of those who occupied California before the rest of us arrived here.

Certainly, our understanding of the belief and thought that structured California Indian life will remain imperfect. Native American traditions, like the souls of their dead, have left the domain of daily life in California. Rock art sites—vulnerable to natural erosion and the increasing ravages of vandals—are likewise gradually giving up the ghost. The information so painstakingly gathered by ethnologists and archaeologists can still be combined with the rock art that remains to give us an inkling of what it meant to the people who carved it or painted it.

Designs as simple and direct as the rayed disk of the sun tell us the obvious: the Indians thought the sun was important. Stars of the nighttime sky—at least certain groups of them—seem also to have been depicted. Orion's belt and the Pleiades, for example, are distinctive in the sky, and there are rock art elements that look like them. While ambiguities may cloud the identities and meaning of so many other rock art symbols, these and other designs are discernible. Celestial images, then, were a likely part of the symbolic vocabulary of California Indians.

Occasionally, an additional clue to the celestial component of California rock art is revealed by the interaction between a symbol and an astronomical event. A number of rock art sites are now known to involve a play of sunlight upon a pictograph or petroglyph at an astronomically, calendrically, and seasonally significant time of the year. Several of these displays take place at the winter solstice. On this date the sun rises as far to the southeast as it will ever be seen from a particular rock art site. During the day the sun follows its lowest, most southerly arc of the year across the sky and sets in the year's most extreme position to the southwest. The winter solstice (the shortest day of the year) usually occurs on the 21st day of December, and it marks what we call the "first day of winter." For the Indians, especially for those in the south, the winter solstice represented the start of California's rainy season. It was a time of colder weather and long shadows. Game, fish, and other food were more scarce. The days were short, and the nights were long.

Actually, the winter solstice is one of the key turning points in the seasonal oscillation of time. California Indians recognized this hinge of the year and celebrated it with ceremonies dedicated to the preservation of cosmic order. For them, and for many traditional peoples throughout the world, the winter solstice stood for the moment of crisis in the cycle of cosmic order. If the balance and order of nature were preserved through this critical time, the sun, the year, the natural order of the world, and all its living things would, in a sense, be reborn.

The solstice was watched and the calendar was kept by specialists—the shamans. Among the Chumash, the shaman-astronomer was responsible for reading and in-

terpreting the sky. Known as an 'akchuklash, he/she was, in a way, an astrologer and a member of the 'antap, the religious cult that officiated in the ceremonial life of the Chumash.

A visible link between the shaman and the winter solstice occurs near Chatsworth, at Burro Flats, where a panel of Chumash pictographs, protected under a sandstone overhang, engages the light of the rising winter solstice sun (plate 10). When the sun ascends from behind the nearby ridge, its light falls upon the outer face of the shelter. Although most of the overhang keeps the light from hitting the paintings, a natural bottomless "window" does let a beam reach inside. Archaeologist John Romani of California State University, Northridge, had noticed this opening on previous visits to the site. The aperture seemed to have been formed naturally, with no sign of human handiwork. Romani speculated that its orientation toward the southeast might have had something to do with the winter solstice. Accompanied by his collaborators, Gwen Romani and Dan Larson, he and several other interested observers visited Burro Flats on the morning of winter solstice, 1979.

The first light that passed through the opening produced an image of a triangle that fell upon a set of five concentric white rings painted on the west end of the rock art panel. The tip of this "arrowhead" touched the second innermost ring and pointed toward the center of all five. This momentary image of a triangle rapidly grew into a large finger of light that extended upward from the bottom of the panel and continued, for a time, to point toward the rings' center.

It is believed that much of the rock art we encounter in California was produced by shamans and related to their spiritual quests for transcendental knowledge and power. We can imagine, then, that Burro Flats was one of those special, sacred places where the shaman would observe and participate in a celestial event—the winter solstice. This sunrise vigil allowed him/her to keep an appointment with symbols, sunlight, and the cycle of cosmic order.

There are other rock art sites that also seem to link carved or painted images with the solstice sun. Edward's Cave (SBa-103), visited by Steve Junak in 1978, is located in Chumash territory in the Los Padres National Forest. There is reason to believe that this site may be astronomically significant, although it is not certain that the event observed is really limited to only the time of the winter solstice. A natural pillar of rock inside the shelter is decorated with a set of five painted concentric rings. At the winter solstice the rings are bisected by the light of the setting sun. Half in shadow and half in light, they seem poised like the cosmic balance that, according to some California Indians, was in jeopardy at the time of the winter solstice.

One of the most suggestive solstitial rock art sites is in Baja California, near the town of Rumorosa. Ken Hedges, curator of ethnology and archaeology at the San Diego Museum of Man, watched what happened there on the morning of the winter solstice in 1975. He discovered that several rock art elements painted on the south wall of the shelter designated LC-44-18 were coordinated with the first appearance and continued progress of a stiletto of sunlight that stabbed across the

39

decorated panel. After nearly reaching the most distinctive image in the cave—a red, humanlike figure thirteen inches high and outfitted with a pair of wavy horns—the sunlight dagger abruptly stopped its motion. Another spot of sunlight then appeared on the other side of the figure. This formed into a second sharply pointed blade of light that inched back to "threaten" from the other side. This dagger then knifed right across the tiny black eyes painted on the face of the red figure and transformed the rock art into a "watcher" of the winter solstice sun. Although the image may represent some supernatural being of importance to the Indians who came seasonally to this area to gather piñon nuts, it could just as easily be a portrait of the shaman.

The skywatching shaman draws power from the sky. It is the realm of mystical shamanic ascent, of the passage of the dead, and of celestial gods. As such, it is the source of cosmic order as well as the stage on which the celestial dramas that reveal that order are played. The cycles of day and night, of the moon's phases, and of the seasons of the year all provide the pattern and direction that seem, to our human brains, to organize the world and our lives. By keeping the calendar, by witnessing the sky, and by ritualizing the natural cycle of the cosmos, the shaman enters the celestial realm and siphons off some of its power. In the belief system of California Indians, people—and in particular the shaman—had a role to play, a responsibility to fulfill. The shaman was a participant, someone who acquired power and used it to maintain the world's balance and order.

In every round of the seasonal cycle, the Indians sensed there was a time of danger for the world's harmony and for the continued well-being of living things. A Chumash myth symbolized this threat to cosmic order in a gambling game played each night by two inhabitants of the sky: Sun and Sky Coyote. Sun was considered very powerful, but he was not necessarily benevolent. If, after a year of this competition, his score was higher, he took his winnings in human lives. Sky Coyote, by contrast, offered a more desirable alternative. His victory meant a proper amount of rain and an abundant supply of food. The score was tallied at the winter solstice when Sun, rising at his southernmost extreme, seemed able to walk out on the world by simply continuing to slip farther south. At this time the shaman tried to affect the outcome of the game by ritually coaxing back the sun. This excursion of the sun was, of course, just a metaphor for the threat to cosmic balance, and the shaman's ceremonies symbolized the celestial power that stabilized and oriented the world. Sky Coyote was a fitting player in this pageant, for he was associated with what the Indians recognized as the one stationary spot in the sky, the north celestial pole. The pole is the place that creates *north* and, therefore, the direction that organizes the landscape. It is the pivot around which the rest of the heavens turn. Sky Coyote is, then, the point of celestial stability. His success against Sun protected the world from imbalance. A coyotelike figure is painted on the ceiling of a rock shelter (Tul-19) in the region occupied by the Yokuts, and a set of rayed rings balanced on his snout suggests the sun (plate 8). This seems to be a portrayal of the same myth. In a symbolic way, the interaction between the painted rings and the winter

solstice sunlight at other sites may be a reenactment of this myth as well. As the tale was played out in rock art shrines, the shaman would fulfill the ritualistic role in the maintenance of cosmic order.

Although the rock art images at these winter solstice sanctuaries are like bridges between the shaman and the sky, they do not usually resemble celestial objects as we see them in the sky. Instead, they are metaphors—tales told in a language of symbols. They stand for the sky—or, rather, for what the sky meant to the California Indians who drew them. There are other drawings, however, that seem to depict more literally the things we actually see in the sky. In a fundamental paper on Native Californian solstice observations, Travis Hudson, Georgia Lee, and Ken Hedges assembled a large collection of possible portrayals of the sun near the distinctive features of a serrated horizon. Ethnographically, we know that the sun's progress through the year was monitored along the peaks of an appropriate horizon by Chumash sunwatchers.

Other examples of astronomical rock art include crescent moons, what may be eclipses, and what look like maps of stars and constellations as the Indians perceived them. A modern survey of this material has been prepared by Travis Hudson (*California's First Astronomers*, 1982). In *Crystals in the Sky*, a pioneering work on Chumash astronomical tradition, Hudson and his coauthor Ernest Underhay identify a pair of complex disks at Burro Flats, each trailing a long tail, as time-lapse portraits of some comets seen in Chumash skies. While this may be so, the images have a dynamic appearance that suggests rapid movement and

change. If they are celestial at all, I would associate them with meteors, and, in particular, with the especially bright and dramatic type known as fireballs. Hudson and Underhay suggested that the Geminid meteor shower, which annually precedes the winter solstice by about a week, was symbolically associated with the solstice. The Geminids are a rich, dependable shower with many bright meteors. As depictions of shooting stars, the Burro Flats "comet" symbols are more in keeping with the winter solstice character of the site.

Even if we are correctly identifying portrayals of the sun, moon, meteors, and stars among the mystifying mixture of rock art designs, we have very little understanding of the use to which they were put. It is only when we know at least some of the rest of the story that we can appreciate their significance. This is why the winter solstice symbols are, perhaps, more accessible. We know, at least in part, what story they relate.

It is a simple narrative, but it is at the heart of our experience with the world. It is the myth of the cycle of cosmic order: order is created, and this is the creation of the world. Order endures, and the world grows. Eventually chaos reintrudes, and the cosmic order is threatened. This round of the cycle contains, however, the seed of the next, for the reemergence—or recreation—of order follows the challenge of chaos.

We see this story staged in the behavior of celestial objects, in the pattern of day and night, in the seasons, in the passage of time, in the cycle of the growth of vegetation, in the lives of animals, and in our own

personal experience of birth, life, and death. Things are born. Things grow. Things die. And things are reborn. Our brains are on a quest for order and meaning in the changes we encounter in the world around us. We find a structure for perception and thought in the myth of cosmic order. Its plot originates in the sky.

The winter solstice, then, is that crucial moment of transformation—the time when Sun seems determined to abandon us and when the cosmic scorecard is to be tallied. Rock art at winter solstice shrines carries celestial connotations because the sky is the realm that governs and reveals the cycles so important to living things.

Other symbols, which might at first seem incongruous, also complement the rock art images connected with the seasons and the sky. This occurs, however, because the language of metaphor is a network of associations. Like poetry, it puts precision in language by expressing relationships with images rich in symbolic meaning. For this reason, then, it is possible to find an emblem of fertility and birth—a vulva symbol—at a solstice shrine, where a shaman witnesses the rebirth of world order in the display of winter sunlight.

One of these symbolic representations of the female sexual zone is a petroglyph scratched on the inside of a small, womblike rock shelter known as Window Cave (SBa-655). The vulva symbol is roughly oval in shape and is partially split along its main axis by a single vertical line. Several filaments, or rays, radiate from the oval itself, and it is connected to two or three other carvings—difficult to make out—including a long, thin triangle. It points down to an eight-spoked wheel, the type of symbol sometimes identified as a sun disk.

Archaeologist Laurence W. Spanne noticed, in 1978, that light from the setting winter solstice sun entered a natural window at the southwest end of the shelter and opposite the entrance. A long streak of sunlight gradually edged along the wall and stopped where the inside surface reached a corner. Around it and at the same height as the invading vein of sunlight was the "sun disk" petroglyph.

Window Cave is on present-day Vandenberg Air Force Base, and Tranquillon Mountain, a site known to have been sacred to the Chumash, is framed by the aperture. Spanne also observed that the mountain served as an ideal horizon feature for pinpointing a last gleam of the setting winter solstice sun as it slipped down the north side of the mountain's profile and behind a spur of rock.

A possible solar motif and its interaction with winter solstice sunlight classifies Window Cave with other solstice sanctuaries, but the presence of the vulva symbol is, perhaps, unexpected. Further consideration, however, prompts recognition of the congruence between the "fertility" symbol and the womblike architecture of the shelter itself. Sunlight's penetration into this sacred chamber mimics the fertilization of the woman's womb. From the womb new life is born. In parallel with this concept, the new year—and really, the world's order and balance—is recreated in the solstice shelter. It is a sacred realm because cosmic order is

revealed there. Revelations of the world's fundamental pattern and structure are what constitute the sacred.

These connections between human sexuality and the sky are found elsewhere in California Indian tradition, and they are sometimes explicit. The late Beverly Trupe and John Rafter, two investigators of rock art in the Mojave Desert, have drawn attention to a Chemehuevi myth recorded by Carobeth Laird, in her book *The Chemehuevis*. They have related the myth to the petroglyphs inscribed upon some of the very large boulders at Counsel Rocks (SBn-291), a site in the eastern Mojave's Providence Mountains. Huge boulders have fallen from the rock cliffs into a roughly semicircular arrangement. One of these big stones, known informally as Womb Rock, is cut through by a cavity and passage that opens to the east. The passage is just large enough to permit a person to squeeze through it, and its floor is discolored and unnaturally smoothed, suggesting that people may, in fact, have made their way through this opening in connection with some ritual. Below the exit, on the Womb Rock's lower face and among a large number of petroglyphs, one of the carved designs stands out. It looks like a vulva symbol—a bisected oval—but seven lines hang from the bottom of it, and there are two protrusions, one to the left and the other to the right, from the sides. Chemehuevi tradition refers to the "seven whiskers" of the sun. This may explain the seven downward dangling filaments; a similar idea about the sun's beard may be embodied in the "whiskers" attached to the vulva symbol in Window Cave.

The myth noted by Trupe and Rafter describes a woman who lived in a cave. When she emerged each morning she would lie down and open her thighs to the sun. On one occasion she was impregnated by the sun's light and eventually gave birth to his twin sons. With this myth in mind, John Rafter has equated the peculiar protrusions on Womb Rock's vulva symbol with a pair of outspread legs. A similar motif accompanies a seven-rayed disk on a neighboring rock.

We cannot be certain about the use of the decorated boulders at Counsel Rocks, but interpreting the imagery in terms of female genitalia and the sun is reasonable. It is possible the "birth canal" of Womb Rock was a prop on the stage for puberty rituals. Or instead, the idea of birth may identify the site as a place of shamanic initiation. Puberty and shamanic initiation both are turning points in life—transformations linked with the idea of rebirth.

We may not be able to discern the exact purpose of the site from its rock art, but the underlying theme seems evident. The fertility imagery we encounter is really an invocation of the cycle of cosmic order. It is given, of course, as a metaphor drawn from the pattern of human life. A cosmic dimension to this theme is provided by a link to the sky, in this case through the sun. The sky allows us to contrive a metaphorical matrix that orients, organizes, and punctuates our lives. It is sacred knowledge expressed by California Indians in the celestial component of their rock art.

E. C. Krupp
Los Angeles, California

43

Who is like me
My plumes are flying—
They will come to rest in an unknown region
Above where the banners are flying.

Song of the Slighted Princess
Chumash

Plate 10
The possibility that winged creatures are shamanic depictions of the trance-state experience of flying is one area of important rock art research currently being done. These paintings, in a well-protected rock shelter in the Simi Hills, display a wealth of symbolism. Photo: William D. Hyder.

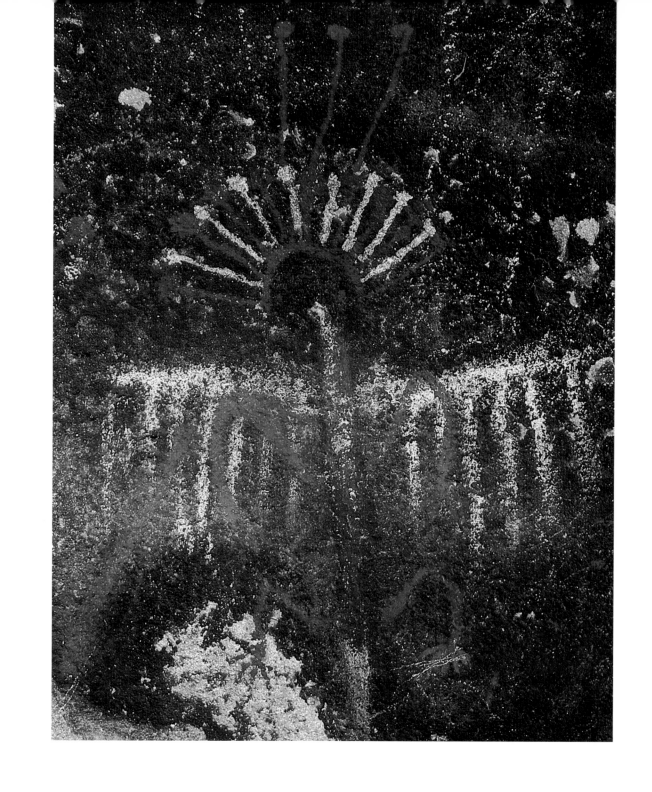

The Shamanic Origins of Rock Art

... But to suggest the derivation of such art solely from the immediate needs of the stomach, as some writers have done, is to perpetuate the myth of "primitive" man as a purely material creature whose intellectual pursuits were focused only or even mainly on sheer biological survival. Anyone who has spent time with such peoples or studied their often highly complex mythology and rich oral literature knows this to be false, or at least simplistic. Certainly no one would deny the primary importance of physical survival. But ... the goal of the biological and cultural continuity of the society presupposes the delicate interplay and balance of a whole series of material and metaphysical constellations, under the guidance of the shaman.

— Peter T. Furst (1974:44–45)

The study of rock art, more than most archaeological research, allows us to see into the minds of earlier peoples and discern patterns of religious belief and shamanism. Rock art is a visible record of mental images. It is now generally agreed that much of the rock art produced by hunting and gathering peoples is the result of shamanistic activity. Many lines of evidence further suggest that rock art includes direct representations of phenomena experienced by shamans in their quest for the spirit world.

Shamanism is the religion of all hunting and gathering cultures, and it forms the basis for many more formalized religions that retain shamanistic elements. Careful examination of the artistic record tells us that the role of shaman has been with us at least since Upper Paleolithic times, while evidence from burial practices suggests active shamanism from the time of Neanderthal man onwards. A shaman may be male or female, but most shamans in the ethnographic record are men (references to the shaman as "he" in this essay are largely a matter of convenience, but reflect the prevalence of men in shamanistic roles).*

The concept of supernatural power is basic to shamanism. In these belief systems, supernatural power resides in all things to varying degrees but is concentrated in certain places, objects, animals, and individuals. Power can be gained, lost, or manipulated for purposes of good or evil. Since power is derived from the supernatural world, supplication to or contact with the supernatural world is essential to manipulate and control that power for the common good. The control of supernatural power is a basic function of the shaman.

The shaman is that individual in a culture who has the ability to make contact with and enter into the supernatural world. As indicated by Mircea Eliade's definition of shamanism as a body of "archaic techniques of ecstasy," the shaman enters the spirit world through the medium of the ecstatic trance. The trance state may be induced spontaneously, by sensory or bodily deprivation such as sleeplessness and fasting, through techniques of meditation, or by the ingestion of hallucinogenic substances. Eliade tended to dismiss the role of hallucinogens in shamanic practice, but recent research by scholars such as Peter T. Furst, R. Gordon Wasson, and Richard Evans Schultz has revealed the importance of hallucinogens. The sacred fly agaric mushroom appears to be the basic means for the achievement of ecstatic trance in the northern Eurasian area where classic shamanism was first defined. Hallucinogens are especially important in New World

*EDITOR'S NOTE: Throughout this volume, the pronoun problem has been resolved in a similarly convenient fashion.

46

shamanism, and the primary examples are mushrooms and peyote in Mexico (and in the Southwest and southern Plains where peyotism has taken hold in recent times) and several species of *Datura* in the southeastern and southwestern United States, including California. Unlike other types of hallucinogens, the daturas are extremely dangerous plants, used only under strictly controlled ritual circumstances.

Basic shamanistic beliefs occur repeatedly throughout the world and are present in native religions of California. Among these are supernatural power received through trances, visions, and dreams; use of hallucinogens as aids in perceiving the supernatural; concepts of illness caused by soul loss or magically placed intrusive objects; curing accomplished by a shaman who sends his own soul after the lost soul; the importance of birds and bird symbolism; the ability of a shaman to transform himself into other forms, particularly animals; the concept of a universe organized into levels with a cosmic axis at the center marked by a sacred pole, world tree, or cosmic mountain which serves as the means by which the shaman can travel from one level of the universe to another; and the symbolism of the skeleton as the seat of essential life force.

Specific duties of a California Indian shaman may include divination to foresee future events or find lost objects, curing, weather control, guidance of the soul to the afterlife, and the maintenance of fertility for human beings, plant and animal food sources, and the world in general. An important function of the shaman is to oversee world renewal ritual, often at the time of winter solstice, when the sun stops its path along the horizon and begins its return to warmth and new growth. The sun is universally recognized as the primary source of all life and power.

When the shaman enters his trance, he is transformed. He becomes a powerful animal or bird and travels to the spirit world. In his mind and in the belief of his people, the transformation is literal. The visual and sensory imagery of the trance state, especially with the use of hallucinogens, is taken as proof that the supernatural world has been attained. A basic trance characteristic is the sensation of flight; thus the importance of bird symbolism in shamanism. However, flight is the means by which the shaman travels to the spirit world no matter what form he takes in his transformation.

Animal familiars are helping spirits in animal form, through which the shaman receives supernatural advice and sends messages to the spirit world. Because of their power of flight, birds are important animal familiars, but almost any animal, and sometimes plants or even sacred places that serve as oracles, can be a familiar source of advice and aid. Animal familiars and the important animals of transformation are among the shamanistic concepts that can be directly represented in rock art. Before discussing such representations, it is important to place rock art in the broader context of the basic relationship between shamanism and art in human culture.

As expressed in the quotation that introduces this essay, Furst points out that a culture's survival depends upon the "multi-dimensional equilibrium" of a whole series of material and metaphysical factors that must

The sun rises from the east and goes to the west, all the spirits follow him. They leave their bodies. The sun reaches the door and enters, and the souls enter too. When it is time for the sun to fulfill his duty he emerges, for he lights the abysses with his eye, and all who are in the dusk resurrect.

Silverio qonoyo of Santa Inez

Plate 11
Known to local ranchers as the "Blessing," the painting, on a boulder of vaqueros sandstone in the Carrizo Plain, is similar in style to that found at most of the other rock art sites attributed to the Chumash. Photo: Mark Oliver.

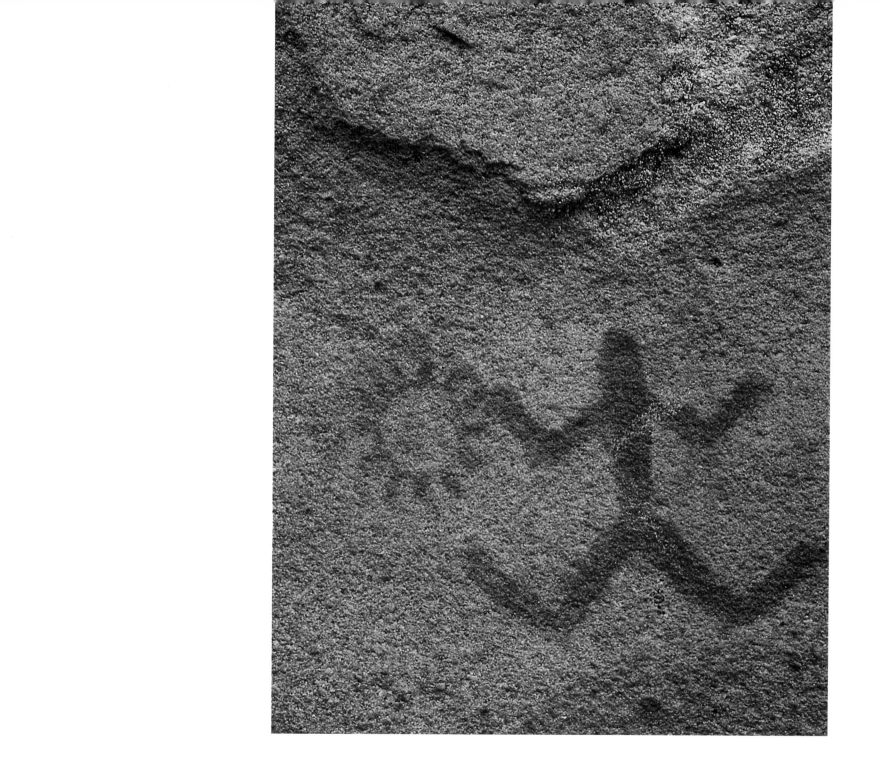

be maintained in their proper relationships for the world to survive. To maintain this balance, the shaman marshals all his powers and talents. "Not the least of these are special talents of communication, of which artistic expression can be considered the highest level" (Furst 1974:45). Shamans are chosen individuals who may excel in various forms of artistic endeavor, including music, dance drama, oration and storytelling, carving, and painting. Since the shaman is "supernaturally 'elected' to the practice of shamanism, his superior creative gifts are to be expected and add to his charisma and power" (Furst 1974:45).

Perceptions of the supernatural derived from the trance state are indescribable, but something of their content must be conveyed to the people for whom the shaman exercises his power. The trance experience is "so impressive, so striking, so dramatic, that in order to communicate its meaning—usually by means of ritual—shamans have had to improvise means of communication and thereby have given birth to various art forms" so that "laymen of a society see and hear realities in a way that enforces social cohesion, reinforces the symbolic representation of their world, and promotes the mental health of the community at large" (Bean and Vane 1978:124). Shamanism and art are inextricably bound together, and it appears that they are so joined in the earliest human art. Rock art encompasses some of the earliest known art, and continues up to modern times. Speaking of Paleolithic cave art, Giedion points out that the mystical experience signified immediate contact with invisible realities: "Without this the symbols and the other representations of primeval art are not conceivable. The mystical experience permeates the whole atmosphere of the caverns" (Giedion

1962:279). Andreas Lommel expressed it succinctly in the title of his great work, *Shamanism: The Beginnings of Art.*

Clearly, not all rock art is shamanistic. It remains for us to demonstrate the shamanic implications of rock art and to clarify which kinds of rock art have valid shamanistic associations. Shamanism permeates the rock art of hunting and gathering cultures, and shamanistic elements often can be identified in rock art associated with other types of religious systems.

Interest in shamanistic interpretations of rock art has been fostered in large part by studies of ethnographically documented shamanistic arts in New World cultures, most notably the work of Gerardo Reichel-Dolmatoff among the Tukano-speaking Indians of Colombia, and the work of Peter T. Furst and his colleagues among the Huichol of western Mexico. These studies, while they do not relate directly to rock art, allow us to place rock art in a broad cross-cultural context. They dovetail nicely with what is known about shamanism on a worldwide basis, and they provide numerous specific parallels with what are perceived to be shamanistic elements in rock art. It is apparent that, particularly in hunting and gathering cultures and in cultures with strong ties to their hunting origins, documented similarities in shamanistic belief and practice result in broad similarities in shamanistic art. We cannot, for the most part, provide specific interpretations of rock art motifs and compositions, but we can place them in general shamanic context and define constellations of possible meanings.

As early as 1952, Horst Kirchner published a shamanis-

tic analysis of the famous "wounded bison" panel at Lascaux, and the well-known "sorcerer" transformed shaman with a bow at Les Trois Freres has long been recognized as shamanistic. In the New World, however, shamanistic interpretation of rock art began in the early 1970s, with two major exceptions.

In 1967, W. W. Newcomb, Jr., published an explicit analysis of the rock paintings of the lower Pecos River, Texas, which placed the rock art in the context of a hypothesized shamanistic society: "If the shamanistic-society hypothesis is pursued a bit further, one can readily imagine that the custom of painting shelter walls in the lower Pecos country may have originated when a shaman emerging from a trance, very possibly induced by mescal beans, attempted to visualize his hallucinations or dreams . . ." (Kirkland and Newcomb 1967:79–80). The assignment of lower Pecos paintings to shamanistic-society ritual is based on a number of specific resemblances between elements in the rock art and similar features in the historic mescal-bean medicine societies of the same area. The paintings appear to predate the medicine societies by more than 1,000 years, but nevertheless, "this kind of hypothesis offers a satisfactory, reasonable, and comprehensive interpretation for the Pecos River style pictographs" (Kirkland and Newcomb 1967:75). The Pecos River paintings include splendid representations of such shamanistic concepts as shamanic flight, animal familiars, visionary imagery, power animals, and a host of other elements that are perfectly understandable in the light of general shamanistic knowledge, regardless of what specific interpretations might be placed on them.

Even earlier than Newcomb's analysis of Pecos River rock art, in 1958, Baumhoff, Heizer, and Elsasser produced a shamanistic interpretation of the Lagomarsino petroglyphs in Nevada that still stands as one of the best explanations for the enigmatic "abstract" rock art of the Great Basin. Among Great Basin Shoshoneans, would-be shamans would seek power through dreams at specific power spots, particularly springs and water holes that might be inhabited by the "water babies" from which some shamans got their powers. The authors noted that "the association of the petroglyphs with the permanent spring leads to the proposal that native curing-doctors (shamans) may have been responsible for the rock markings" and that the motivation may have been the acquisition of supernatural powers and the performance of increase rites (Baumhoff, Heizer, and Elsasser 1958:4). Curiously, this interpretation, which is consistent with known shamanistic practices in the area in which the rock art is found, was omitted when the 1958 paper was republished in the 1962 report on prehistoric rock art of Nevada and eastern California by Heizer and Baumhoff. The concise and economical interpretation of the rock art as attempts by the shamans to "depict the objects of their dreams or visions" was replaced with a statement of the hunting-magic hypothesis for which the Heizer and Baumhoff report is famous.

In 1965, interpretive comments occupied barely four pages of Campbell Grant's pioneering study of Chumash rock paintings. Based on Chumash ethnographic data known at that time, it was possible to conclude only that "it seems certain that most of the paintings in the Chumash area were the creation of the shamans and were for the ceremonial use of particular regional groups" (Grant 1965:90). Now, with the in-

Your elder relative you must think well of; you will also welcome your daughters-in-law and your brothers-in-law when they arrive at your house. Pay heed to this speech, and at some future time you will go to their house, and they are going to welcome you politely at their house.

Do not forget this that I am telling you; when you are old like these old people, you will counsel your sons and daughters in like manner, and you will die old. And your spirit will rise northwards to the sky, like the stars, moon, and sun.

From Counsel to Girls
Luiseño

Plate 12
Paired, yellow anthropomorphic figures grace the ceiling of a large rock shelter overlooking the Kumeyaay village site of Wikwip in eastern San Diego County. Photo: Ken Hedges.

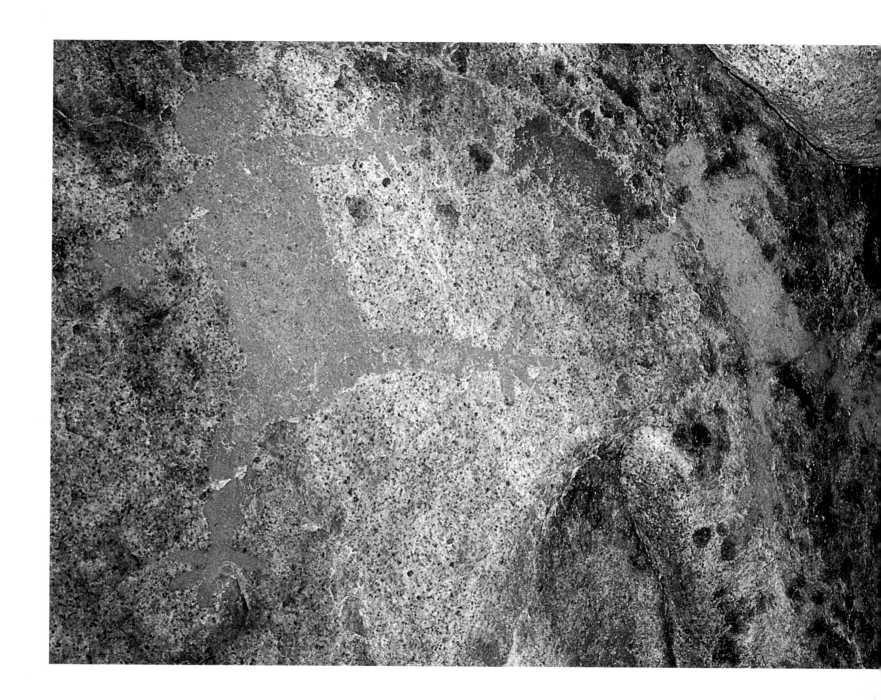

creased availability of the J. P. Harrington notes, Chumash researchers are finding ample support for the shamanistic origins of Chumash rock art, even though the specific information needed to support this interpretation is still to be found.

The landmark publication in shamanistic interpretation of rock art is the study of the Peterborough, Ontario, petroglyph site published under the title *Sacred Art of the Algonkians*, by Joan and Romas Vastokas in 1973. The major accomplishment of this work is the detailed iconographic interpretation of individual glyphs, using archaeological, ethnographic, and art historical techniques. The interpretation is thoroughly grounded in shamanism—of the Algonkians in particular, but with reference to shamanism on a worldwide scale. The interpretations, though derived through established methods of research, are often highly speculative, "but even speculation may provide the general reader with an insight into the problems of rock art research and suggest to the archaeolgist new avenues of approach in his efforts to reconstruct the prehistory of North America" (Vastokas and Vastokas 1973:5). The study demonstrates the utility of wide-ranging ethnographic analogy, and makes a significant point regarding examination of the entire site as an artistic unit: "The Peterborough Petroglyphs, therefore, as a work of art, through the organization of its individual images and the relationship of the site as a whole with its environmental and cultural continuum, constitutes a document of multiple formal dimensions which will permit a tentative ideological reconstruction and serve to verify interpretations based upon ethnohistorical, ethnographic, and archaeological grounds" (Vastokas and Vastokas 1973:5).

Shamanistic interpretation of rock art has followed two basic trends. The first deals with the identification of visual representations of shamanic concepts in the rock art. A second approach deals with the interpretation of certain rock art motifs, compositions, and sites as direct representations of the visionary images of the trance state, or as art styles derived from such images. Both types of research help lay the groundwork for detailed interpretations of specific rock art sites as loci of shamanistic activity.

The basic concept of supernatural power is represented in rock art. Just as Western religious art uses the convention of the halo to indicate holy status, shamanistic art uses a set of basic conventions to indicate individuals who possess supernatural power. Horns, wavy lines, rays, rows of dots, and other emanations from the head indicate the presence of this power. An individual so endowed is invariably a deity, a supernatural being, or a shaman possessed of such power. Peter T. Furst has observed that horns are nearly universal symbols of supernatural power and of spiritual and sexual potency. The Huichol of West Mexico use horns as symbols of sacred shamanic power. Among the Ojibwa, horns and wavy lines projecting from the head and body are emblematic of supernatural power, both good and evil. In Pueblo cultures, horns are attributes of many of the kachina beings, while the Navajo state that horns give power to the bearer.

These examples, among many others, provide cross-cultural perspective for similar representations in California rock art. In the Coso Range, numerous figures have horns or other projections coming from the head. In some instances the horns take the form of projectile

points. Figures with rays coming from the head are common in Tulare rock art of the southern Sierra Nevada foothills, and horned figures are found in Chumash rock art. In Kumeyaay territory at the southern end of the state, such figures are rare, but one of them has a significant association with winter solstice ritual. Other horned figures are found in petroglyphs of the desert canyons of northern Baja California and farther south in the central peninsula.

Animals endowed with supernatural power are an important part of rock art imagery the world over. While the specific animals differ from region to region, the basic categories are the same: horned animals (deer, elk, mountain sheep, ibexes, antelope), bears, large felines (mountain lions, jaguars, tigers, lions), canines (coyotes, wolves), and serpents (rattlesnakes, anacondas) are among the more common groups.

The concept of horns as symbols of supernatural power is closely associated with the importance of horned and antlered animals. From the deer of Upper Paleolithic cave paintings to the deer of contemporary Huichol art, there is remarkable continuity in the arts and their associated beliefs. To the Huichol, the deer is a deity intimately associated with corn and peyote, and the transformed shaman becomes deer. In the rock art of the lower Pecos River, there is a profusion of deer, deer antlers, and antler headdresses in association with supernatural beings or shamans. In South Africa, elands are considered sacred, deities assume the form of elands, ancestors of the people are elands, and shamans are transformed into elands. Such concepts regarding the role of these animals in native cultures provide data for reinterpretations of similar animals in California

rock art.

In the Coso Range of eastern California, numerous petroglyph drawings of mountain sheep have long been considered evidence of elaborate hunting magic cults. It appears that such explanations, while not totally incorrect, are at least simplistic. Mountain sheep petroglyphs, some of them larger than life, can be viewed as power animals, symbols of supernatural forces in the universe. Like other horned animals in other cultures, the sheep may be deities, ancestors, the souls of deceased humans, or transformed shamans. Their frequent association with elaborate supernatural anthropomorphs and a wide variety of apparent visionary images indicates that we are dealing with a complex system of beliefs regarding the supernatural world.

In classic Eurasian shamanism, the most powerful of the shaman's helping spirits are the spotted panther and the striped tiger. In the New World, the jaguar fills this role in Central and South America, while in North America the mountain lion is a recurring power animal. Important examples are known from the great murals of central Baja California and the cave paintings of the Pecos River in Texas. The mountain lion from Petrified Forest, Arizona, is one of the best known petroglyphs in the Southwest. In the Coso Range, some mountain lions are very catlike, while others are rendered more schematically, retaining their upturned tails. A black and white mountain lion in profile appears among Yokuts paintings at Exeter Rocky Hill, while a red mountain lion seems to fly across the roof of the shelter at a Kumeyaay site in northern Baja California.

Serpent motifs are common and widespread, from the very ancient ground drawings in the California deserts to the rain serpents of Arizona and New Mexico. Serpents are almost invariably the guardians of the underworld, controlling the sources of water, life, and fertility. Beliefs about the rain serpent are remarkably parallel in areas as widely separated as Australia, South Africa, and the Southwest. These similarities may be viewed as evidence that the associated beliefs are very ancient, moving with man wherever he went in populating the earth.

In many rock art sites in the American west, we see the frequent occurrence of small animals in positions attendant to anthropomorphic beings that bear shamanic attributes. These figures correlate well with what we know about animal familiars—sources of supernatural power and avenues of communication with the spirit world. Thus, we see two felines in contact with a horned human carrying a staff at Three Rivers in New Mexico, or entire flocks of small birds around the heads and shoulders of imposing mummylike figures in the Barrier Canyon style from Utah. In the lower Pecos River rock paintings, we see representations of flying shamans accompanied by flocks of small birds—precise renderings of shamanic flight. Small deer guard the shoulders of some Pecos River figures, while serpents perform the same function at the heads or feet of Barrier Canyon figures. These compositions are some of our best examples of shamanistic concepts represented in rock art.

A common theme in shamanism is the death, dismemberment, and rebirth that the shaman experiences in the initial trance states that occur when he is "called" by the supernatural powers. The experience sometimes is horrendous. The shaman, in his vision, may see himself reduced to bones, which are then reassembled and transformed into a new body. In this way the shaman is reborn into his new role as intermediary between his people and the spirit world. The skeletal motif is common in worldwide shamanic art, and shamanic beings often are represented with their skeletons exposed. Contrary to common belief, these are not death images, but symbols of shamanic rebirth. Although figures in California rock art frequently show interior patterns—some of which could represent supernatural powers contained within the individual—specific skeletal motifs are uncommon. Where they occur, as at Canebrake Wash in San Diego County, they probably reflect this basic shamanistic belief.

The ultimate responsibility of the shaman is fertility in its most general sense—the continuance of life and the culture of which he is a part. Specific representations of sexual activity are relatively rare in North American rock art, but they do occur. A panel among the petroglyphs at Inscription Point in Wupatki National Monument, Arizona, is a case in point. It is noteworthy that each of the anthropomorphic couples in this panel is composed of a horned figure and a figure with a featherlike projection from the head. The copulating figures are in direct association with a large rain serpent, emphasizing the fertility theme of the panel.

In their discussion of the great female figure drawn around natural fissures in the rock at the Peterborough petroglyph site, Joan and Romas Vastokas say that the female image might be interpreted as a materialization

of the spirits of nature. The site itself is seen as a symbolic uterus, a means of access to the sexual energy of nature upon which the shaman can draw for the benefit of mankind. Similar images occur elsewhere in American rock art. In the Coso Range, a female figure with a natural fissure forming the vulva presents a similar concept, and examples also are known from the Pacific Northwest. A similar meaning may be inferred from the obvious emphasis of the vulva on a petroglyph representing a female rain toad—an image with strong fertility associations—at Puerco Ruin in Petrified Forest, Arizona.

The most common fertility symbol in rock art is the representation of the vulva itself. The Chalfant Bluffs site in Owens Valley, California, for example, has over 100 of them, some carved around natural crevices and fissures in the rock. In Baja California, vulva glyphs frequently occur in shelters containing the great mural paintings. There are no known vulva glyphs in southern California Kumeyaay rock art, but a similar function is ascribed to natural rock formations resembling female genitalia. These were used in ceremonies for women unable to conceive.

Many so-called abstract designs, often very elaborate and colorful, have continually resisted interpretation. These have become the subject of one of the newest and most exciting fields of inquiry in the shamanistic interpretation of rock art. Recent research in biophysics and an increasing body of data on shamanic trance experiences in contemporary cultures have led to the interpretation of some of these designs as representations of visions seen during trance states. Such rock art designs may be either portrayals of specific, individual trance experiences or designs drawn in the context of an art style derived from such experiences. In either case, the basic phenomena are the same. Because of the individualistic nature of these apparent visionary images in rock art, it appears that most examples that can be interpreted in this way are representations of specific trance experiences.

Studies by Max Knoll have clearly demonstrated that subjects under the influence of a hallucinogen have difficulty in producing adequate drawings of hallucinogenic imagery. Drawings made afterwards, however, are much more sophisticated, detailed, and complete. In rock art studies, it is proposed that patterns interpreted as visionary images are records of that imagery produced after the trance state has ended. We are not asserting, as some have assumed, that shamans produce rock art while under the influence of a hallucinogen.

In Colombia, the work of Gerardo Reichel-Dolmatoff has provided thorough documentation of a shamanistic art style derived from representations of the things seen by Tukano Indians in their hallucinogenic visions. Peter T. Furst and others working with the Huichol of western Mexico have collected an extensive body of visionary art which provides comparative data for rock art studies. When rock art is compared to this material and to medically documented examples of hallucinatory imagery, numerous specific and striking parallels are revealed.

At the simplest level, we are dealing with phenomena known as phosphenes—the varied geometric patterns that appear in the visual field when no visual stimuli

are entering through the eyes. Basic phosphenes can be made to appear by gently applying pressure on the eyes with the lids closed. Phosphenes occur spontaneously with migraine headaches, extreme fatigue, and in a variety of other instances, including the "stars" one sees with a sharp blow to the head. In all these cases, the brain is interpreting nonvisual stimuli as visual imagery. Phosphenes occur within the structure of the eye and brain. While they are imperfectly understood, it is clear that the same patterns recur in an individual, and similar patterns occur in different individuals. Studies of electrically induced phosphenes have resulted in a standard corpus of phosphene designs, and one of the major results of Reichel-Dolmatoff's work with the Tukano was the demonstration of a close correlation between phosphene motifs and Tukano design motifs. A similar correlation has been pointed out between phosphenes and Chumash rock art motifs, and the same types of similarities occur between phosphenes and rock art motifs from many design areas.

Patterns seen in the initial stages of drug-induced trance states are phosphenes, and the complex hallucinations that follow represent the elaboration of this type of imagery under the influence of the hallucinogen. The typical drug-induced trance state begins with flashes of color and geometric figures (phosphenes), followed by familiar scenes and faces and unfamiliar or fantastic scenes, faces, and objects. While hallucinations tend to exhibit certain recurring form constants, there is an infinite elaboration of detail, so that visionary imagery may include almost anything. Because of this, any rock art design *could be* a visionary image, but it is pointless to speculate on this when the design consists of subjects that could just as easily have come from

everyday, ordinary reality. Current studies are focused on recurring, identifiable visionary imagery, preferably that documented from more than one source, both medical and ethnographic. Building upon this base, it is possible to suggest that obviously "fantastic" motifs, designs, or compositions, or such designs combined with ordinary subjects, are representations of hallucinatory imagery beyond the phosphene stage, particularly if these designs also include phosphene elements.

In Tukano art, all of the basic design motifs are phosphenes experienced during the initial stages of the hallucinatory experience. The Indians also are capable of producing elaborate drawings of the later stages of their visionary experience, as are the Huichol, who make yarn paintings of their visions and incorporate hallucinatory imagery into weaving and embroidery. It is important to emphasize the difference between the initial stages of neurophysiological stimulation, marked by the occurrence of phosphene patterns which will tend to occur in all human subjects under similar conditions, and the later stages of hallucination which are characterized by figurative imagery of a projective nature. As pointed out by Reichel-Dolmatoff, mythological scenes seen by the Tukano can be seen by them only, because interpretation of the visions depends upon culturally determined models. Nevertheless, even figurative imagery is subject to general levels of interpretation based on broad similarities in both shamanistic concepts and visionary imagery.

It has recently been proposed that the concept of phosphenes as a stimulus to rock art must be kept separate from the examination of hallucinogenic imagery in rock art. As the discussion by Reichel-Dolmatoff

clearly shows, phosphenes represent the initial stages of the hallucinatory experience, and the two phenomena cannot be separated. It is important to note that phosphenes discussed in the context of Tukano aboriginal art are phosphenes produced by the hallucinogen. Nowhere is it suggested that we are dealing with spontaneous or pressure phosphenes in the documented aboriginal arts, even though it would be impossible to separate them from hallucinogenic phosphenes if both were represented.

Visual representations of hallucinogenic experiences are marked by other characteristics as well, such as attempts to portray movement, transparency, and the superimposition and combination of design elements. These factors are well documented in studies of hallucinations, and it is important to note that superimposition in rock art may be a deliberate portrayal of superimposition and transparency in a visionary image. At Gillespie Dam in Arizona, for example, there are several examples of design elements drawn as if transparent, superimposed over elements that are allowed to show through. Certain Chumash rock art panels exhibit this same characteristic, such as the fantastic multilayered being at Edgar Rock in San Luis Obispo County, or the well-known horned anthropomorph with the bird coming through its body at Pool Rock. In the case of the Pool Rock figure, the bird is made invisible with the application of water and reappears as it dries. It is intriguing to speculate that this characteristic may have been deliberately contrived to show the phenomenon of transformation or the presence of the alter-ego within the body of the shaman. In any case, the superimposition appears to be deliberate.

Chumash rock art is particularly rich in phosphene imagery and examples of what appear to be full-fledged visions. In some instances Chumash designs are outlined with white dots that duplicate a characteristic of datura visions. Chumash art and the other examples discussed here are only a few of the many styles in which the rock art meets all of the basic requirements that would enable us to describe it as visionary imagery. No other reasonable interpretation has yet been offered.

Most rock art is representational—we simply have to determine what it is that is being represented. Studies of phosphenes and hallucinations can provide many insights into the sources of rock art images. With the close association between shamanistic practices and the visionary imagery of the trance state, such studies bring us a little closer to an understanding of the meanings of rock art.

Shamanism is the basic religion of mankind. Evidence of shamanism is found not only in rock art, but in all the arts of hunting and gathering cultures throughout space and time, and in the art and religious practices of many cultures—including our own—that may be far removed from their hunting origins. The shaman enters a separate reality when he undergoes transformation in the trance state. In rock art we have images from that separate reality which we are only beginning to understand.

Ken Hedges
San Diego, California

White people are a reincarnation of the souls that had gone west. They had a different color, were reincarnated in a lighter color, and spoke a different language. The color and languages of whites and indians are different, but the noble principles of the soul are the same. For this world is a single congregation.

A story told Fernando Librado
by his grandfather.

Plate 13
The Chumash pictograph site of San Emigdiano, one of the most spectacular in North America. Photo: Sandra Uchitel.

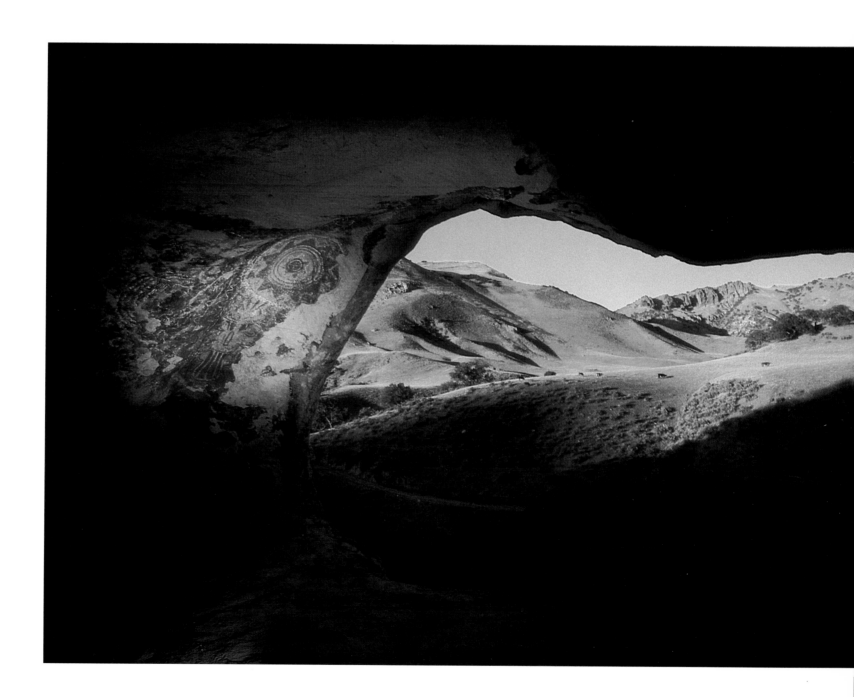

The Rock Art of Baja California

One of the surprises of the remote peninsula of Baja California, geographically isolated from all the developments of New World civilizations, is the presence there of the most elaborate painted rock art in North America. The Spanish, who initially settled Baja California in the sixteenth century, believed that the Indians of that area were among the simplest and most primitive peoples in the world. In the central part of the peninsula, huge galleries of what has been called the "great mural" style of rock art exist. Caves and shelters hold dozens and even hundreds of paintings of deer, mountain sheep, humans, and other figures. Many are done in life size, with panels as much as 100 feet in length forming a giant billboard of naturalistic art. Designs are painted in red, black, and white as well as in other colors. The Spanish, when they first came upon these impressive galleries, considered that the art must have been made by an ancient and extinct race, since they could not relate the giant mural style to the simplicity of the Indians being missionized in the 1760s.

Scholarly study of the rock art of Baja California has for the most part been quite recent. Spanish missionaries saw some of the sites in the 1700s, although they prepared no illustrations of the art. They did, however, add their own art, in the form of Christian crosses, to some sites. Painting their own religious symbols was an attempt to counteract the pagan activity of the original rock art. The first scholarly studies were those of Leon Diguet, a French explorer who published drawings and general descriptions of some of the rock art sites in Baja California in 1895 and 1899. Between 1949 and 1954, several additional reports were written about one of the sites discovered by Diguet, the site of San Borjita south of Mulege. The first colored paintings reproducing Baja California rock art are from this cave and appeared in two Mexican publications: *Artes de Mexico* (1954), and the magazine *Impacto* (1950). Some ten years later the American mystery writer, Erle Stanley Gardner, was preparing a series of travel and adventure stories about Baja California. He observed the largest and most elaborate of the giant mural sites out of the window of a helicopter while flying down one of the rugged interior canyons of the Sierra San Borja. Shortly thereafter, I was able to return with another of Gardner's expeditions and publish an account of four sites in *American Antiquity* (1966). Gardner's photographs were the first published records of several of the sites. These illustrations appeared in *Life* (1962) and also in several of Gardner's travel books on Baja California.

In the 1970s, there was a renewed interest in studying the rock art of Baja California, and several excellently illustrated books appeared. Those with large color plates include the books by Harry Crosby (Copley Press, 1975) and, in Spanish, Enrique Hambleton (1979). A scholarly summary placing this art in cultural and archaeological context is Campbell Grant's *Rock Art of Baja California* (Dawson's Book Shop, Los Angeles, 1974).

The large human figures in the great mural style range from one to nine feet in height, with most about life-size. They are frequently bisected in color and painted half-red, half-black. Many of the animals are similarly painted. Long white lines representing arrows are frequently shown sticking in the animals. Arrows are also associated with some human figures, but in such cases the arrows are usually drawn across the body of the

figure. The animals portrayed are primarily food resources: deer, mountain sheep, rabbits, turtles, and fish. The art has been assumed to be related to hunting magic and to control of the creatures of nature, particularly those used for food. However, there is clearly an abundant symbolism and set of ritual beliefs included in this art, and further study is needed to decipher the meaning of the variations in color, ornamentation of the human figures, and the presence of small ancillary figures associated with some of the major drawings.

The great mural style is almost entirely naturalistic and represents living beings (plate 14). Of the very few geometric elements, checkerboard figures are the most common. This style is not at all like any of the rock art found in Alta California, and it is confined to the central part of the Baja California peninsula. In that isolated region, the style is widespread in the cliffs and caves of the interior mountains. Several dozen sites are known, and new ones are regularly discovered, although the latter tend to be smaller locations, since the major sites have, no doubt, been found.

The only objective evidence for dating of the great mural style is a single radiocarbon date on a wooden artifact from Gardner Cave, the biggest of the painted mural sites. This artifact was made about 600 years ago and is apparently contemporaneous to at least some of the cave paintings.

Other styles of rock art are found in the same area as the giant mural style. Indeed, there are at least five quite distinctive styles of rock art in central Baja California. Many sites of pecked petroglyphs are found, and in some of these there are pecked figures quite similar to those found in the painted style. However, other styles, both pecked and painted, are found for which there is limited evidence on age and meaning. Examples of some of the other styles may be found in Meighan and Pontoni (1978). It appears, however, that the central part of Baja California has had extensive and diverse rock art over at least the last couple of thousand years, and that the production of rock art was an important activity to the people who lived in this area. While the initial discovery and description of Baja California rock art has been done, many more detailed studies are needed to define the styles and interpret their age and meaning. It is not unlikely that new styles of rock art remain to be discovered as well, so this is one of the more important areas for rock art studies in the future.

So far the Baja California sites have been protected by their isolated location, and as a result have experienced minimum damage from vandalism. The painted sites are largely inaccessible. Many of them show considerable natural erosion and weathering which is slowly causing the paintings to disappear. Fortunately, they are, in general, free of initials, bullet holes, and similar vandalism which tends to be present at sites visited by many people. The sites of petroglyphs, particularly those on small boulders that can be moved, have not fared so well. One large site was almost 30 percent destroyed within a few years of becoming accessible by road, and a few sites have been largely destroyed in road-building itself. Even in this remote region there is a clear need for prompt and thorough documentation. The rock art that remains must be recorded before it is further damaged or destroyed.

Clement W. Meighan
Los Angeles, California

Solo el dios,
escucha ya aquí,
ha bajado del interior del cielo,
viene cantando.

Miguel León Portilla

Plate 14
Gardner Cave (Face C) in Baja California was recorded by Clement W. Meighan as part of the Erle Stanley Gardner Expedition in early 1962. Rock art on this remote peninsula seems to be unique, unlike most of what is known in Alta California. Photo: Clement W. Meighan.

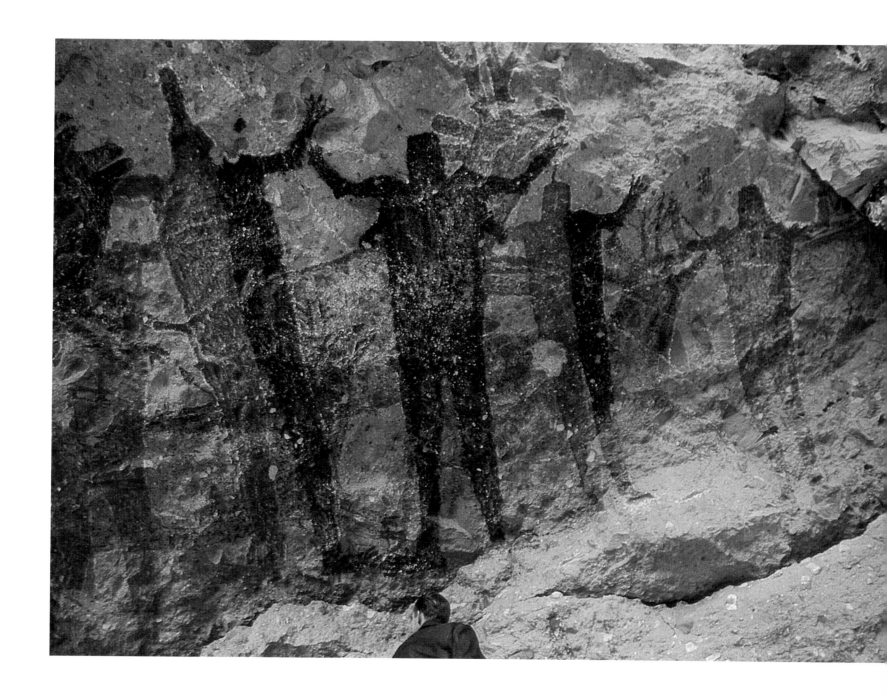

The Great Galleries of the Coso Range: California's Most Extensive Rock Art Site

Man's development and the growth of civilization have depended, in the main, on the progress in a few activities—the discovery of fire, domestication of animals, the division of labor; but, above all, in the evolution of means to receive, to communicate, and to record his knowledge.

Colin Cherry, *On Human Communication*

The penchant humans have had for leaving designs painted and carved on enduring surfaces throughout the world extends back into prehistory—long before the development of a translatable, written language. The Native American is no exception to this worldwide phenomenon.

Rock walls, cliffs, caves, and isolated boulders stand as testimony to the Early American predilection to leave a mark upon the earth. Perhaps nowhere is there a grander display of the diverse forms of petroglyphs than California. Certainly some of the world's finest outdoor galleries exist in the middle southeastern section of California, in mountains of the Coso Range.

These sites are located on the missile range of the Naval Weapons Center, a sprawling ordnance test area situated between the Panamint Range to the east and the Sierra Nevada on the west. The canyons containing the petroglyphs are found scattered throughout the impact area, and thus are restricted to travel. This becomes a blessing, since it also means that the Navy goes to some lengths to protect the petroglyph sites.

The day's journey to the sites is in itself an adventure.

It becomes a bone-jarring ride up Mountain Springs Canyon, located on the Navy base in Inyo County, California. The climb is from 2,100 feet elevation at China Lake to nearly 5,700 feet at the southern end of Etcheron Valley. The summer rains cut spring-breaking ruts in the narrow dirt road, and in the winter the snow lies too deep for passage.

In the summer, when there is access with Navy permission, the air sits motionless in the canyon where temperatures hit 100 degrees and more. While braving the twisting washboard road that snakes up the canyon, the hardy traveler passes historic remnants by the score; tailings from abandoned mines and dozens of miner's prospects. These long-deserted dreams dot the landscape like bits of colored confetti.

Nearby Mammoth Mine and Wild Rose Mine, crumbling into the certain decay that time brings, are mute evidence of a once prosperous mining district. An old cabin with roof caved to the ground now plays host to a procession of animals that seek water from the springs that give the canyon its name, a scant 100 yards distant.

Toward the top of Mountain Springs Canyon, where the country begins to level, the visitor is suddenly thrust into a virtual forest of giant Joshua trees. The air is cooler now at the 5,700 foot level, and the beauty of these huge, high-desert plants is overwhelming. Here the Joshua tree grows to a height of twenty feet, with many spreading to an equal diameter.

Once the visitor climbs out of the canyon, he is in Indian country. The beautiful expanse of Etcheron Val-

ley stretches ahead. The dry bed of Carricut Lake, devoid of plant life, desolate, lies perhaps four miles in the distance. The pinyon pine grows abundantly on the high mountains of the Argus Range surrounding this peaceful valley. The sweet nut of this tree provided a staple diet for the people who first inhabited the area. However, as happened to so many seminomadic peoples, they met with increasing drought and its resultant depletion of game, and they emigrated from the valley hundreds of years ago.

Turning west out of Etcheron Valley, the rough dirt road climbs through a picturesque high-desert canyon. The washboard road breaches the crest and plunges abruptly down onto Wild Horse Mesa. Three miles of choking dust, and finally the visitor sees the final sign pointing to the destination lying one-half mile to the north.

The reward for this strenuous trip into hot, dusty, desolate high-desert country is Little Petroglyph Canyon, one of the United States' most remote National Landmarks. This scenic spot, carved in antiquity out of the extensive lava flow, and Big Petroglyph Canyon four miles to the northwest, constitute one of this nation's attempts to preserve the heritage left it by the early dwellers on the land. Little Petroglyph Canyon, formerly Renegade Canyon, is approximately nine miles in length and is literally covered with petroglyphs. Hardly a rock remains that does not have some design incised upon it, and hundreds of boulders contain scores of geometric, zoomorphic, and anthropomorphic carvings. Big Petroglyph Canyon is larger still, with proportionally that many more glyphs. And these

are but two of several glyph-filled canyons in the Coso Range.

This rock did not come here by itself.
This tree does not stand of itself.
There is one who made all this,
Who shows us everything.

*Yuki Shaman's song from
the Obsidian Ceremony*

Plate 15
One of the ubiquitous sheep designs found throughout Big and Little Petroglyph Canyons, Coso Range. Research speculation has most often centered upon hunting magic as an interpretive explanation. Photo: Phillip A. Giesen.

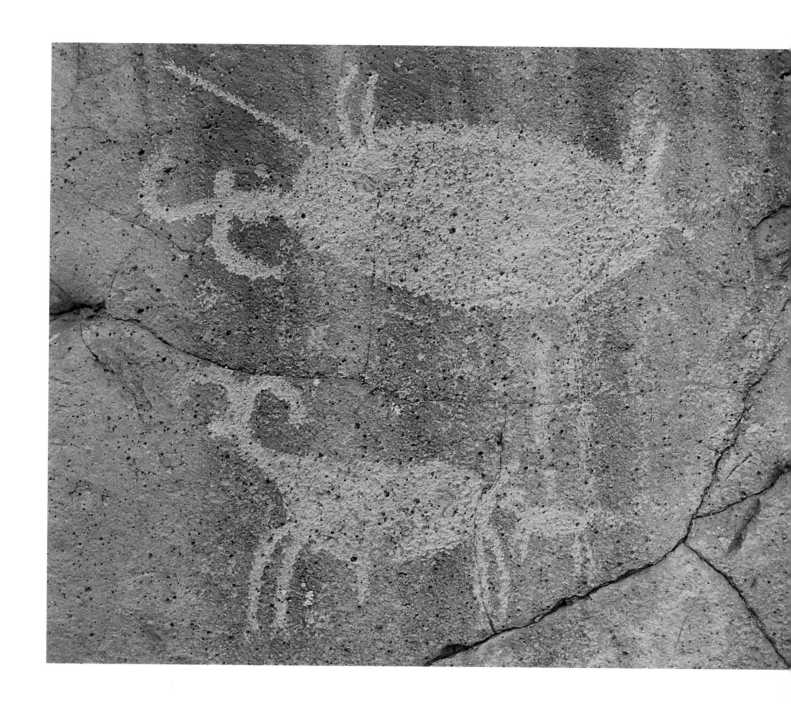

Both Big and Little Petroglyph Canyons begin rather inconspicuously from near ground level, but quickly deepen and become narrow. Through eons of time, when water flowed constantly down the canyons, the cutting and shaping took place. Today, an occasional flash flood will still scour the canyon walls with water-carried sand, and the rough basalt is worn smooth in the present dry creek bed. The battleship-grey stone remains cool to the touch and provides a deep contrast to the canyon walls stained a dark brown to nearly black by the desert varnish or "patina." It is upon this darkened portion of the stone that the early inhabitants carved, incised, chiseled, pecked, and scratched their amazing designs.

The walls in Little Petroglyph reach three hundred feet in height before the canyon opens into Indian Wells Valley, while Big Petroglyph Canyon plunges to a depth of over six hundred feet. Both of these canyons empty into Airport Dry Lake. However, at one time the entire Indian Wells Valley was the site of an ancient Pleistocene freshwater lake, approximately fifteen miles wide, twenty-five miles long, and two hundred feet deep. This abundant water supply provided the necessary ingredients for human habitation, as countless archaeological sites attest today. The petroglyphs found in these canyons number among some of the most beautiful in the country, and the profusion of design elements make the area the most decorated in Southern California.

In spite of the dramatic research significance of the area, there was no single book devoted exclusively to the Coso Range until 1968 and the publication of *Rock Drawings of the Coso Range*. This volume, written by Campbell Grant, James W. Baird, and J. Kenneth Pringle, set about to thoroughly research the area. The authors not only set down the locations of the petroglyphs, but supply the reader with insight into styles and subject matter, techniques of production, even interpretation. Research is currently being done in the Coso area, but until further information is forthcoming, this volume remains the best source material.

As early as Mallery's pioneering *Picture Writing of the American Indian* (1893), a rock art tradition prevalent over the entire Great Basin region of Nevada, eastern California and adjacent areas had been recognized by archaeologists. Petroglyphs of similar type appear in areas widely separated, and many so-called abstract designs are present throughout California and the Southwest. The delineation of style areas in rock art is a complex task, yet one of primary importance. Because styles are characteristic of particular cultural periods, adequate definition of styles is basic to rock art analysis.

While the catch-all term "Great Basin Style" is less than perfect (Hedges 1981), it has been generally used to define the Coso Range petroglyphs. The designs are classified as geometric, or rectilinear and curvilinear, and are found throughout the canyons. These designs often resemble squares or rectangles, some laced with cross-hatching or other interior markings. Often the box-shape will have rounded corners, and dots may be sprinkled within the confining lines. In many instances the designs are single lines that meander, interconnect with others, or just terminate abruptly (see Glossary).

A second type of design that occurs prolifically in the Coso Range is the zoomorphic representation, most particularly the sheep figure (plate 15). Some boulders contain herds of sheep, with legs sketched as if in an attempt to give animation to the animals. There are sheep in repose, six to eight feet long. Sheep are carved over other, more ancient designs. One of the side canyons to Big Petroglyph has such a plethora of these animal designs carved into the basalt cliffs that it has been named Sheep Canyon. Its length is over eight miles, and it contains nearly 3,000 designs.

At some distance from Big Petroglyph Canyon, but still within the context of the Coso Range style, stands a large boulder at the upper end of a small valley that was often used by the Indians as a camping area. Carved on this imposing monolith is a single sheep measuring approximately six feet from nose to tail (plate 16). The commanding position of the animal as it gazes over the valley gives one pause and a ringing inference as to its significance. The reading of Coso sheep and deer designs as part of hunting magic or food increase ritual is certainly possible. Another and perhaps more fruitful line of inquiry expands this shamanic interpretation of Coso symbology to include vision quests and trance imagery (see Hedges, this volume).

Perhaps the most enigmatic Coso drawings are the anthropomorphic or godlike figures. Found throughout the area, they range from simple stick-figures to tall, imposing forms complete with elaborate costumes and headdresses. There seems to be little pattern to the distribution of the anthropomorphic designs. There will be several boulders stretching along a canyon floor, each with a single figure, then abruptly a group of three or four (or more) anthropomorphs all carved on a single rock. Many times these forms are found situated in the midst of geometric designs. And, as with the sheep, superpositioning is often seen.

The anthropomorphs display a variety of elaborate body or internal patterns, including cross-hatching, diamond shapes, strings of dots, zig-zag lines, or a combination of patterns. Other common motifs include fringed "skirts" and ear-bobs. Many are holding some object in their outstretched hands; perhaps a ceremonial staff, or some badge of office. These objects have also been interpreted as atlatls.

The petroglyphs of the Coso Range have been carved into basalt, a hard, fine-grained igneous rock. Incision is often ¼ to ⅜ inch deep, and in many designs, the entire figure is pecked out. There are even examples of negative carving, where the background has been chipped away, creating a relief design. The patience, the endurance, the artistic imagination of the primitive artist/shaman, using only a stone tool to peck or chisel into this hard rock, evoke admiration from modern humans equipped with carbon-edged steel and space-aged technology for fashioning tools and recording computerized history.

Yet in the Coso Range of California we have glimpsed but one of thousands of sites spread throughout the United States. There is great significance in the Coso Range petroglyphs as they relate to other cultures, other prehistoric contacts. This significance cannot be adequately measured just in terms of its artistic or ar-

In desert hills I rode a horse slack-kneed with thirst,
 Down a steep slope a dancing swarm
Of yellow butterflies over a shining rock made me hope
 water. We slid down to the place,
The spring was bitter but the horse drank. I imagined
 wearings of an old path from that wet rock
Ran down the canyon; I followed, soon they were lost,
 I came to a stone valley in which it seemed
No man nor his mount had ever ventured, you wondered
 whether even a vulture'd ever spread sail
 there.

From "An Artist"
Robinson Jeffers

Plate 16
These mural-sized petroglyphs of sheep on basaltic cliffs, Coso Range, Inyo County, are visible from the canyon below. They are superimposed over the efforts of earlier artisans who incised anthropomorphic elements as well as smaller sheep motifs. Photo: Kathleen Conti.

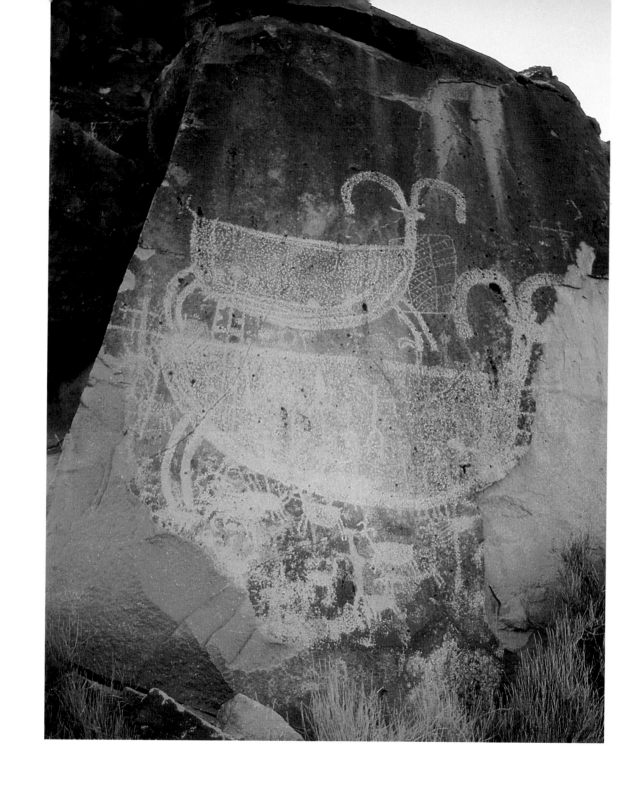

chaeological importance. How much value can be put upon the Egyptian pyramids? the Mayan temples? the Pleistocene rock art of Lascaux and Altamira?

Still, as precious as this petroglyph record is, it stands in jeopardy. The great archaeological sites of the world have their protectors. As an example, Lascaux in considered off-limits and closed to all but a few eligible scientists. (Even then, no more than five people at a time may visit the famous cave!)

The Coso Range stands a better chance of enduring than most rock art sites in the United States. Access to the Naval Weapons Center is restricted, and permission to visit the area must be obtained before venturing forth. The list of requirements set forth by the Navy includes an essential demand that visitors travel in convoy. Signs are posted throughout the area restricting travel to established roads, as the casual traveler may encounter missile and bomb duds in the fields or hills.

The entire Coso area is a cluster of ancient Indian sites. Not only does it contain the exquisite rock art, but several habitation and temporary camping sites have been excavated, indicating that Great Basin Indians used the area in 2,000 BC or earlier. Flakes of obsidian litter the ground, and the infrequent rains wash arrow and spear points to the survace. It is, in short, a living museum of the early cultures.

In the Coso Range, as in all of the rock art sites in America, we hold in our grasp the single most important artifact from early humans—their only attempt at communication. Past generations have looted ancient Greece, raped the Egyptian Nile Valley, and carted off the treasures of Mayan and Incan antiquity. Ours is a chance to reverse this trend. We have the privilege to behold the past in our own time. We also have the power to preserve and maintain for future generations the silent heritage left by our predecessors in America.

Frank Bock
El Toro, California

Black Canyon: A Rock Art Proving Ground

The project described in this essay is one approach to solving a difficult problem. Increasingly throughout the world, civilization is threatening archaeological treasures. The threats take various forms but the outcome is consistent—artifacts that have survived thousands of years are being lost in the span of a few decades. This problem took on a personal dimension for me many years ago when I began to see more and more destruction, through vandalism as well as natural causes, of the petroglyphs I had been studying in the California deserts. I decided at that time that I had a responsibility to save these artifacts for future generations. There are two basic approaches I could have taken: preserve the artifacts from further damage or create a permanent record of the artifacts. Preservation of the artifacts themselves will require a combination of political activism (e.g., attaining national monument status for much of the California desert) and technological innovation (e.g., developing a method to protect the rock carvings from natural deterioration). Since my abilities and expertise lie in the area of recording, I have attempted to develop a system for creating a permanent record of petroglyphs so that future generations will be able to study and enjoy them.

Black Canyon is located in the western portion of the California Mojave Desert. Black Canyon, a north-and-south-running prehistoric riverbed on the west side of the Black Mountains of Southern California, is about ten miles long. It is some thirty-five miles northwest of Barstow. Its headwaters drain from the Superior Dry Lake basin area and its mouth empties into the Harper Dry Lake. Water runs through the canyon only during rains. There is only one spring or well still viable. Its water level varies from ten to twenty-five feet below the surface, depending on the season and year. We find many relics of man's use of the canyon: hunting blinds, rock walls, rock enclosures, rock rings, rock alignments, previously inhabited caves, cement watering troughs for animals, and even abandoned cars. I selected this site for my work for two reasons. First, the glyphs there are in imminent danger. The rock surfaces are deteriorating from natural causes and, because the site is so readily accessible even to passenger cars, the increasing recreational activity in the area has increased the amount of vandalism. Second, the site has a high density of glyphs confined to a limited area.

It should be noted here that the petroglyphs of Black Canyon are not particularly unique in their general style. They are classed as quite typical of the so-called Great Basin style (Heizer and Clewlow 1973), although Hedges has pointed out that this style is not rigidly defined. He suggests instead that these glyphs be referred to a broadly defined Archaic Great Basin tradition. For the most part the designs are "abstract" or nonobjective. There are a few figurative elements. We find a small number of what we describe as big-horn or sheeplike designs, now and then a reptile or lizard, and on rare occasions a stick figure or anthropomorph (see Glossary).

Black Canyon has been used as a north/south trade route for thousands of years. In modern times, the canyon served as a freight route between Panamint City and San Bernardino for gold ore and borax mule trains.

Before that the Kawaiisu (and possibly the Chemehuevi) used the passage (Hopa 1976). While no direct record exists for prior times, it is our best estimate, based on dating of cultural evidence as well as other Mojave glyphs, that the canyon has been in use for at least ten thousand years (Turner and Reynolds 1978).

Dating of petroglyphs anywhere is a problem. For the glyphs discussed in this essay, the problem seems insurmountable. It appears that there is a tremendous time span between the earliest and most recent petroglyphs in Black Canyon. Some of the designs pecked into the surface have darkened to the virtually black color of the stones from which Black Canyon gets its name; they can only be seen as a different texture. By contrast, some of the glyphs are as bright as if they had been carved today. In many places around the world the age of petroglyphs can be estimated by datable subject matter such as atlatls, specific projectile point types, or historic design elements. It is also possible to date a glyph that is buried under a datable horizon, in which case the glyph must predate the deposition of that horizon. Unfortunately, none of these situations are applicable to Black Canyon.

The canyon has a great variety of rocks and minerals. Of particular interest is the abundance of silicious material such as jasper, chalcedony, quartz, and rhyolite. These are the rocks that the lithic cultures needed for making their tools. One major mineral in this group that is missing is obsidian. Ancient toolmakers must have enjoyed working with obsidian because it gives such a sharp edge when knapped and it is an easy stone to work with. A few tools of obsidian have been found in Black Canyon, but these tools (or their raw material) must have been acquired through trade. The canyon also has a diversity of gem stones, from amethyst to zircon, which attracts modern-day rock hounds.

The canyon and the surrounding areas support a typical desert ecology. There is a wide range of flora and fauna. While none of these seems to be, at the moment, of great commercial value, some faunal species, particularly the jack rabbits, coyotes, and cougars, do attract hunters.

It is a pleasure to see that some of the present natives of Southern California are attempting to preserve the canyon and all of its beauty. In the past, off-road vehicles have torn up the desert floor with careless cross-country driving. The desert ecology is extremely delicate and some of this damage may be irreparable. One off-road club even went so far as to carve its club name into a basaltic cliff. Now, however, this same club has turned its efforts towards protecting the area. At the headwaters of Black Canyon, in a small side area known as Inscription Canyon, they have done a wonderful thing. As visitors approach this site, they find themselves stopped by a barricade made of old telephone poles. At its own expense, the club hauled these poles in, sunk them into the ground, and fitted the cross beams together so that vehicles can no longer enter into the canyon. Since the canyon is only a few hundred feet long and is easily walked, there was no reason to drive into this area, thereby destroying it. The effort of individuals can do much to protect our natural treasures.

The Bureau of Land Management is also doing its best to preserve the canyon. Not only do they patrol the entire area, but they have also posted signs at many of the major glyph sites. These signs explain what the glyphs are and ask that visitors help to protect them.

The above-described efforts notwithstanding, the petroglyphs of Black Canyon are in danger. It was the goal of this project to find and make a permanent record of every glyph in the canyon area before any more were lost. We decided to include the carved and pecked graffiti made in modern times because it too is an archaeological artifact which, to some future scholar, may have as much value as any of the older glyphs. While we could not anticipate every need of future generations, it was our goal to include any information that might be relevant and to have the information in an accessible format. The method described below was developed and refined with this in mind.

Technical Features

Three different techniques were used to record the glyphs: (1) a form to provide a written description of key elements; (2) a 35mm photograph; and (3) a detailed ink drawing. Each of these techniques is described in detail. Although there is some redundancy in using three recording techniques, each makes a unique contribution to a complete record.

Recording Form

The recording form has three sections. In the first section a series of fill-in-the-blank questions precisely locates a given glyph and provides a unique serial number for identification purposes. The second section has a series of multiple-choice questions relating to how the glyph was made, color, nature of cut areas, type of design, etcetera. The third section provides a space for a rough sketch of the glyph to aid in identification.

Photographic recording technique. *Turner*

35mm Photographs

Each glyph was photographed using a 35mm camera and Eastman Ektachrome film. We tried a number of different approaches. Polaroid shots were taken so that we could know at once whether the photo was viable or not. Black-and-white prints and black-and-white slides were also taken. We settled on the Ektachrome slides as the most useful because the glyphs show up

much better in color. Ektachrome slides can be developed in the field each day so that we know which shots must be retaken. The film is easily developed and one does not even need a darkroom. Given current technology, the only truly permanent photo record today is black and white. Ektachrome life is estimated at 50 years before fading occurs. Slides, by themselves, are not primary documentation. They are most useful as tools in producing good drawings. The making of a black-and-white photo record should therefore be an important part of any rock art documentation effort.

In each photograph a slate was held next to the glyph. The glyph's identification code was written in chalk on the slate so that all photos were clearly identified. A standardized slate size was used in all cases so that the slate also served as a scale when looking at glyph photographs. The slate was placed parallel with the rock face in a position that did not cover any part of the design being photographed and in such a way that all four corners of the slate would be visible in the picture. The camera was held at a right angle to both the rock surface and the slate (see illustration). It was held as close to the stone as possible, the minimum range being the point at which the slate filled no more than half the field seen in the viewfinder.

Ink Drawings

The photographs are a useful record but they often do not capture the essence of a glyph. For publication purposes we needed a record not only of the design itself but of the texture, style, type of line, and so forth. We developed a drawing technique that accomplished this

for us. This drawing approach also clarifies glyphs that are simply too faint for photographic reproduction. In the ink drawings we not only include a depiction of the glyph, but also its relation to the edge of the rock and/ or any cracks or gas-bubble inclusions that might be related to the glyph.

The procedure for making these drawings is painstaking. The photograph, field sketch, and record sheet are all used at the drawing table. The slide is projected onto a piece of Strathmore 100% rag bristol board. The glyph image is adjusted by matching the slate in the photograph to a standard scale that uses a one-inch-to-one-foot ratio. The glyph is correctly scaled and is carefully outlined with non-photo blue pencil. Next, the slide image is enlarged to maximum dimension on a regular projection screen so that every detail can be seen clearly, including the technique with which the glyph was made. The image is compared with the field sketch and the comments on the recording form. The penciled outline on the bristol board is then traced in with a technical pen and black ink (a size triple-O is used for fine lines and a size O for most of the rest). The pen is used in somewhat the same manner as the stone tool was used on the glyph: dots for pecking, one-way lines for scratching, and back-and-forth lines for abrading. This work, of course, cannot be done by the novice; it requires the expertise of a skilled and meticulous illustrator. It also helps if this artist is familiar with the field and has seen the petroglyphs in situ.

The procedure described above was developed and field-tested over a fifteen-year period at a range of sites. After five seasons of field work in Black Canyon, the

system has been subjected to rigorous tests of reliability and revised as necessary. The system does require trained personnel; however, we have found that it is entirely practical to train even inexperienced volunteers on site while the project is in progress.

Early on in the project we realized that there were thousands of glyphs to be recorded in the area. Since it was our goal to record them all, even down to simple marks or incomplete designs, a systematic, repetitive search of every inch of rock surface was necessary. Changes in lighting, plant growth, and the very nature of the dark patina covering the rocks made this a difficult task. It was necessary that the exploration groups (usually 3 to 4 people per group) include at least one experienced and trained glyph finder and that areas be reexplored at different times of day. The end result of this painstaking procedure is that every rock in Black Canyon was inspected at least four times.

When a glyphed rock was found, the finder placed a scrap of paper on it, held in place by a small rock. We originally used our recording form for this purpose because we thought it would be great having them there when we went to record that particular boulder, but we found that overnight the little creatures of the field delighted in shredding them to convert to nests. We grouped glyphed rocks into "sites," a site being any glyphed area that was at least sixty-five feet (20 meters) from any other glyphed area. Exceptions to this definition were made when dictated by natural barriers or when subsequent exploration found new glyphs between sites, but generally it was possible to stick with the sixty-five foot rule.

After an area had been thoroughly explored and tagged, a map was made. The map included distances between boulders. The direction the boulder was facing was also noted, using the 16-point compass rose. All maps and glyphed boulders were tied into a permanent datum point of one kind or another (e.g., an existing well or obvious landmark). Each glyph was given a unique code designation made up of the abbreviated site name, the boulder's number, and the glyph's alphabetic identifier. For example, the fourth glyph on rock number 16 at site C in the Big Bend area is labeled "BBC-16D" (i.e., BB= Big Bend; C= site C; 16= boulder number 16; D= glyph number four on that boulder). Whenever possible, we kept the existing local names for sites, but often we had to make up a name using some local feature like a big bend in the canyon floor.

After the mapping was completed, crews went through the sites and undertook the actual recording process. When an area was completed, the marker papers were left in place until the photographic film had been developed and poor photos had been retaken as necessary. Then, and only then, did we go around and police the area, removing any paper markers (or scraps of paper left for us by the rodents).

A discussion of this project would not be complete without an explanation of how the funds and manpower were acquired. When I decided to begin the project I considered all the usual approaches to funding, ranging from university research grants to bake sales. Any of these could have been used successfully, but I was fortunate to find one that was ideal for my needs—

Earthwatch. Earthwatch is a nonprofit organization that promotes improved understanding of science and the environment by involving lay volunteers in field work. They arrange for individuals to take their vacations as participants at the field site. They charge the vacationer a fixed fee for the stay and pass a portion of that fee on to the researcher to cover food and housing expenses for the volunteer. The vacationer benefits by getting an exciting, inexpensive vacation that at the same time allows him/her to make a significant contribution to science. The researcher benefits by having a pool of interested helpers and some supplemental funding. My project would never have been accomplished in the time available if it were not for the Earthwatch program.

So far, I have discussed only the technical aspects of the

Ink drawings, Black Canyon.

Turner

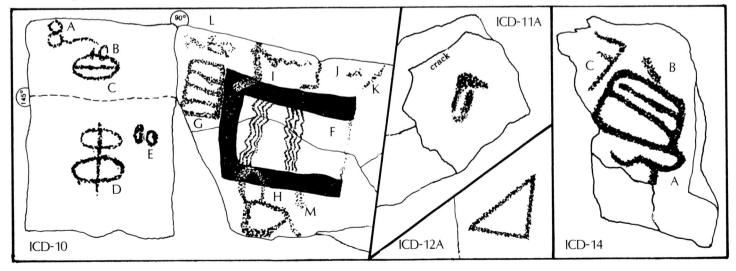

project. While the project has been fun and interesting in and of itself, it is the nature and meaning of the glyphs that have always been my chief interest. Interpretation is a subject that I have tried to avoid because the primary purpose at this point is to record the glyphs. One would have to be much more stalwart than I, however, not to question and wonder about the meaning and purpose of the glyphs. While there is no "rosetta stone" as yet, some possibilities do come to mind. I have a strong feeling that a number of the glyphs have to do with astronomy. Research on the myths and legends of the Chemehuevi, some of whom probably occupied the Black Canyon area, supports this viewpoint (Carobeth Laird, personal communication, 1981). Their oral traditions show a strong interest in the stars, sun and moon. We find many glyphs that may suggest these objects of the heavens and have even found a couple of anthropomorphs that have a crescent moon for a headdress (or is it only my imagination?— the designs could represent a headdress with horns instead). We have asterisk symbols that could be stars, radiating disks that could be suns, and trailing lines that could be comets.

There are other subjects that seem to be discussed in the glyphs. For example, it seems that some of the glyphs may be referring to such things as rain, plant growth, dancing, and snakes. However, all of this will have to be investigated at a later time, after the canyon has been completely inventoried and recorded. Currently, we are in our sixth and final year. Upon completion, we are planning to computerize our findings and then use that data base to work on the interpretation problem.

Acknowledgements

The successful completion of this project is the result of much effort by many individuals. In particular, I would like to dedicate this essay to the memory of a sorely missed colleague, Beverly Trupe. She made a substantial contribution to all phases of the project.

I would also like to thank John Rafter, the Bureau of Land Management, Rio Hondo College, Earthwatch, and Mobile Inspection Service of Santa Fe Springs for their assistance.

Wilson G. Turner
Whittier, California

In the beginning the world was rock. Every year the rains came and fell on the rock and washed off a little; this made earth. By and by plants grew on the earth and their leaves fell and made more earth. Then pine trees grew and their needles and cones fell every year and with all other leaves and bark made more earth and covered more of the rock.

From a Northern Miwok
Creation Myth

Plate 17
Incised line petroglyph almost completely obliterated by the encroaching lichen and moss identifies a Pomo "baby rock" near Ukiah. Ethnographic data indicate that this rock art probably was created as part of Pomo fertility rites. Photo: Ken Hedges.

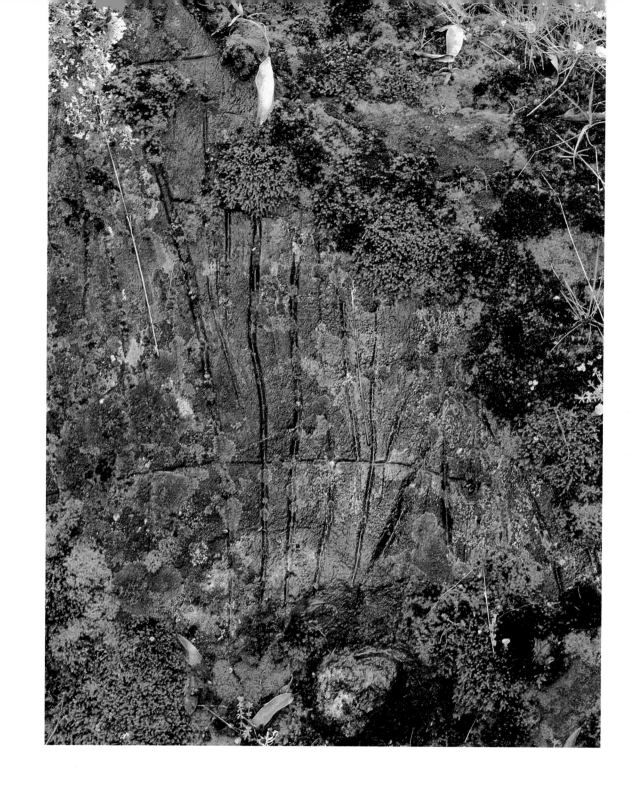

Geoglyphs, Rock Alignments, and Ground Figures

Rock art occurs throughout the world. The human inclination to leave drawings painted and scratched on enduring surfaces extends far back into prehistory. Designs made by pecking, scratching, carving, or abrading on stone are known as petroglyphs, while those that are painted on stone are known as pictographs, or rock paintings. There is yet another rock art technique that has been used to produce designs in the desert pavements on some of the flat terraces in arid regions of both North and South America. These designs have been referred to as *intaglios* because of the sunken design resulting from the removal of surface material or from the depression caused by compaction. Current usage favors the term *geoglyph* (*earth* and *carve*) as being more descriptive as well as consistent with related terminology.

In South America large geoglyphs were constructed on the flat, desolate plains of Nazca in southern Peru. Pebbles were cleared to create straight lines, truncated triangles, geometric shapes, and outlines of animals and plants, in the same way that the geoglyphs were constructed on the terraces above the lower Colorado River in Southern California and Arizona. By removing the dark-colored pebbles, the lighter-colored soil beneath provided the desired design in relief. Among the Nazca geoglyphs are a spider, constructed with a single line approximately 150 feet long, and eighteen bird shapes, one of which is more than 900 feet long and is bisected by a straight line approximately 4 miles in length. Sim-

ilar bird drawings are found on some of the Nazca pottery of Peru.

There is some thought that these geoglyphs were used for making astronomical observations, were places of assembly for ceremonial purposes, or were designations of inviolable burial grounds. Some writers even suggest they were constructed by unknown extraterrestrial beings who came to earth thousands of years ago and made contact with pre-Columbian peoples. Maria Reiche, the German mathematician and astronomer who has devoted her career to the study and preservation of the Nazca geoglyphs of Peru, is convinced the Nazcas created a giant calendar more than 1,500 years ago as an aid to agricultural endeavors in their very harsh, arid environment.

In the United States, public interest in this unique form of rock art has increased as a result of the book and subsequent movie entitled *Chariots of the Gods*. The general public has become aware—unfortunately, in an erroneous context—of the tremendous size of the geoglyphs and of their diversity of designs, some anthropomorphic, constructed on the desert pavements of both North and South America. Many are so large that they can only be viewed with any clarity from several hundred feet above the earth's surface.

In the early 1930s, George Palmer, an ex-aviator of the United States Army, was making a flight from Las Vegas, Nevada, to Blythe, California, when he made an astounding discovery. Flying at an altitude of approximately 5,000 feet over uninhabited desert terrain

along the lower Colorado River, he saw outlines of gigantic human figures more than 160 feet in length. Circling lower over the area, he made careful note of the location and later visited the site again by plane and took some pictures with a small camera. After the photographs were developed, he presented them to Arthur Woodward, Curator of History at the Los Angeles County Museum of Natural History.

Woodward, recognizing the value of this discovery to anthropological science, secured the aid of Lieutenant Minton Kaye and Sergeant Stephen McAlko of the United States Army Air Corps at March Field. Following Palmer's instructions, the aviators relocated the geoglyphs near Blythe, photographed them, and made notes of the best route by which they might be reached by land. Within a few days, Woodward, Dr. Charles Van Berger, Honorary Curator of Archaeology at the Museum, and Lieutenant Kaye visited the location by automobile and made exact measurements and descriptions of the most important designs.

The Blythe geoglyphs are now the best known of the many recorded in North America. These giant figures are located about eighteen miles north of Blythe on high-desert pavement terraces approximately one mile west of the Colorado River. There are four distinct groups of geoglyphs. One group consists of three designs: a man lying with outstretched arms, with the body, from the knees up, within a huge circle; a quadruped appearing somewhat like a horse with long legs and tail; and a serpentine coil presumed to represent a snake. The design of the man is 95 feet long. The

circle, which might have been used as a dance ring, is 140 feet in diameter. The quadruped is 56 feet long, and the serpentine coil is 12 feet in diameter.

The second group of geoglyphs also consists of an anthropomorphic figure associated with a quadruped figure and a coil design. The quadruped and coil here are about the same size as those found in the first group, although the anthropomorphic figure is larger, being 167 feet in length. There is no circle at the second location.

On a third terrace, the geoglyph design is that of a human figure 98 feet long. The fourth Blythe geoglyph consists of two straight intersecting lines, a circle within one of the angles made by this intersection, and a very long straight line beginning at the rim of the circle and extending across it and one of the perpendiculars, going some distance beyond the vicinity of the circle and the intersecting lines.

Although only a few individuals knew of the existence of the geoglyphs along the terraces of the lower Colorado River before 1930, articles in the press describing the giant human figure designs near Blythe created public interest. Second Lieutenant Kaye wrote a four-page article in the *Air Corps Newsletter* of October 18, 1932, entitled "Was There an Advanced Culture in the Southwest?" Two small drawings of geoglyphs reportedly seen near Blythe accompanied his story. Arthur Woodward prepared a feature for the *Illustrated London News* entitled "Gigantic Intaglios in the California Desert," which was published September 10, 1932. A

Then Mastamho took all the people downstream to Avi-kutaparva, to the New York Mountains, and far west to Avi-hamoka, "three mountains," which is toward Tehachapi from Mojave Station.

There Rattlesnake marked himself with white dust, with dark dust, with white cloud, with dark cloud, and went with Mastamho and others eastward to Koskilya near Parker.

From a Mojave Shaman's story

Plate 18
Giant snake geoglyph located near Parker. Blackened desert pavement has been removed to create the figure. The rattles on the tail are easily discernible, as is a rock ring to the right of the head. A less clearly seen aboriginal trail runs through the tail and along the top of the figure. Photo: Ron Smith.

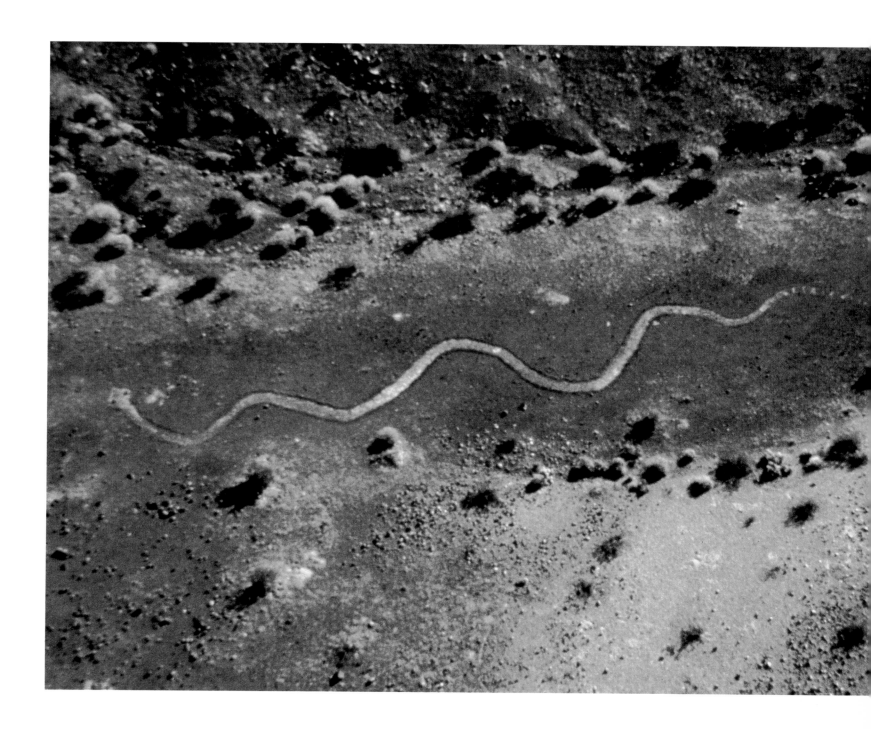

month earlier, Mel Wharton's article, "What Ancient People Fashioned These Titanic Desert Figures?" had appeared in the *Los Angeles Times Sunday Magazine*.

Even though various articles about the large designs made in the ancient desert pavements appeared in publications such as *Touring Topics* and *Desert Magazine*, it was Malcolm J. Rogers of the San Diego Museum of Man who most thoroughly documented these geoglyphs. Rogers' report, entitled "Early Lithic Industries of the Lower Basin of the Colorado River and Adjacent Desert Areas," appeared as *San Diego Museum Papers Number 3*, dated May 3, 1939, and contained a section on "Gravel Pictographs" which discussed the geoglyphs near Blythe.

Rogers identified many geoglyphs extending from Shoshone in Inyo County south into Baja California. On one ridge near Crucero in the Mesquite Hills in San Bernardino County he located eighty-six cairns arranged in lines along the crest of a ridge extending for a distance of 636 feet. In yet another location, long sinuous lines of boulders combined with raked gravel windrows, parallel lines, and other features were included in an area measuring approximately 500 by 2,000 feet. His report of a geoglyph site located at the base of the Riverside Mountains, south of Parker, Arizona, is quoted in full from page 13, "Early Lithic Industries":

This is a group of small ceremonials formed by removing the surface of the desert pavement. They appear to be very old, as there is no difference between the degree of patination on the stones in the cleared area and that on those of the natural surface.

The group is composed of three units. One is an elliptical figure with diameters of nineteen and twenty-one feet. The cleared rim which forms the ellipse is twelve inches wide. The second figure is a simple cleared path forty-two feet long and sixteen inches wide which swells at the west end into a clearing three feet wide. It has the shape of a blunt-ended nail. The third is a composite figure made up of two paths, similar to the one just described, placed side by side, but not parallel. The paths converge toward the head-ends. They are both thirty feet long and have a third headless path fifteen feet long introduced between the diverging ends.

Rogers also reported finding flakes and Yuman pottery sherds on the surrounding surfaces.

The San Bernardino County Museum staff recorded six geoglyph designs near Lake Havasu in 1964. Two are anthropomorphic. One of the human figures, appearing headless, is thirty-two feet long, and the other twenty-six feet long. There is a distinct trail between these two designs. The other geoglyphs consist of a spiral, a single line, two parallel lines, and an arc that bisects one of the cleared pathways. Tramped earth and raked gravel appear to have been the techniques employed in forming the designs. Flakes, pebble hammerstones, and pottery sherds are also located on the desert pavement terraces. The river pebbles found in the alluvium terraces were used extensively as sources of lithic material for various tools.

A parcel of land containing geoglyphs near Needles, California, has been deeded to the San Bernardino County Museum Association. (Deeding geoglyph sites to interested nonprofit organizations or governmental

agencies provides the best method of insuring preservation.) One anthropomorphic figure is visible near the northeast edge of a gravel-covered terrace. This geoglyph was constructed by raking the gravel into ridges to outline the figure. The head is circular, and the arms, extended at an angle from the body, are very long. The area of the legs, especially at the left leg, is eroded, making the design indistinct. A small cleared circle is located near the left side of the head.

A very clear trail passes near the figure. Circular rock clusters were located on the same terrace west of the anthropomorphic figure. Flakes and quartzite river cobbles that are battered from usage are also present. There appears to be a faint packed gravel area in a circular design on the terrace, but it is very indistinct.

Perhaps the most distinct geoglyphs north of Needles on the east bank of the Colorado River are those located near the old Fort Mohave ruins. Two anthropomorphic figures are visible at the ends of a gravel-covered terrace overlooking the wooded river bottom land. The large figures represent human males and were constructed by raking the dark gravel into lines, leaving the lighter-colored soil exposed, and also, by filling in the depressed areas of the head and body of the figures with rock and pebbles of a lighter color. A well-worn trail, possibly of the same age, passes these geoglyphs, leading to the southern point of the terrace where there is a cairn of light-colored rocks within a small, cleared circle. The trail disappears over the edge of the terrace into the river bottom land. Just at the junction of the terrace slope and river bottom are various artifacts, such as

Mojave pottery sherds, flakes, and stone milling tools. The northernmost figure almost appears headless and is about fifty feet long. The second figure is larger by approximately fifteen feet.

It may be that Captain Lorenzo Sitgreaves first reported this site when he wrote in his *Report of an Expedition Down the Zuni and the Colorado Rivers in 1851* the following:

Nov. 7, Camp No. 33—A well worn trail leads down the river, by the side of which in several places were found traced on the ground Indian hieroglyphics, which Mr. Lerous and a Mexican of the party, who had passed many years among the Comanches, interpreted into warnings to us to turn back, and threats against our penetrating farther into the country.

Another early written record of the geoglyphs of the lower Colorado River area was made by William P. Blake in December, 1853. Blake was conducting a geological reconnaissance for Lieutenant R. S. Williamson of the Corps of Topographical Engineers, and while traveling from Yuma, Arizona, toward Pilot Knob, noted his observations as follows:

We, however, crossed several long, path-like discolorations of the surface extending for miles in nearly straight lines, which were Indian Trails. This only change which was produced appeared to be removal or dimming of the polish on the pebbles. There was no break in the hard surface, and no dust. That the distinctness of the trail was made by removing the polish only, became evident from the fact that figures and Indian hieroglyphics were traced, or imprinted, on the surface, adjoining the path, apparently by pounding or bruising the surface layer of pebbles. These trails seemed very old, and may have endured for many generations.

It is regrettable that Blake did not sketch the "figures and Indian hieroglyphics" he saw imprinted on the surface of the desert pavement of pebbles. At such an early date, these geoglyphs could have been observed undamaged. Blake indicated that the technique for imprinting the design was apparently made by pounding or bruising the surface layer of pebbles. This action removed the polish and dark color and a contrasting design resulted.

Rogers identified three basic techniques used in making the geoglyphs. In the first, a relief design was made by aligning or stacking pebbles or gravel in lines or piles. Secondly, by removing sections of the dark-colored pebbled surface on a terrace of desert pavement, the light-colored subsurface would produce the design. The large anthropomorphic geoglyphs near Blythe present a good example of the technique of scraping aside the dark-brown gravel, revealing the underlying tan and gray soil of the terrace and thus producing the human form in contrasting color. The gravel could have easily been pushed aside with hands or feet.

A third technique resulted not by removal of the dark gravel or the abrasion of the dark color from the pebbles, but by repeated treading on the gravel in such a way as to produce a depressed design. Various investigators have witnessed the Bushmen of the Kalahari Desert dancing in a circle for hours and the ground surface over which they danced becoming depressed several inches deep. Trails resulting from foot traffic remain visible for centuries in the desert areas, and modern man's scarring of the deserts will undoubtedly last even longer.

Perhaps the best example of the raked gravel technique used in North America is the well-known Topock Maze located near Needles, California. Like most of the other large geoglyphs, it can only be seen in its entirety from the air because it covers approximately eighteen acres of ground surface. This geoglyph is located near the edge of a terrace overlooking the Colorado River. It consists of parallel windrows of rock and gravel running in several directions; sometimes straight and sometimes curved. Other associated designs include a circle, a cairn, trails, a design considered by Malcolm Rogers as phallic, and a report of two large anthropomorphic figures that were destroyed by construction activities in the late 1880s. Arda Haenszel writes about this geoglyph in detail in the *San Bernardino County Museum Association Quarterly* of Fall 1978. The Topock Maze may have been used by ancient Indians as a runway to escape evil spirits which followed them, especially after they had killed an enemy in warfare.

A somewhat similar geoglyph is located in Death Valley about ten miles north of Stove Pipe Wells. It is constructed in several sections, embodying the same technique as used in making the Topock Maze. When viewed from a nearby height, the geoglyph looks very much like gigantic floor plans for construction of a building. Some viewers have suggested that this geoglyph was used by ancient Indians in ceremonial activities and that each section of the geoglyph represents a certain stage in a progressive ritual.

Very little is known about the reasons for the geoglyphs, who constructed them, or when they were con-

structed. The cultural sequence developed for the Death Valley area by Wallace (1958) and Hunt (1960) indicates that some stone circles, mounds, and rock alignments may have been constructed approximately 2,000 years ago and may predate the later occupation of the area by the Shoshonean language groups.

Yuman language groups have long occupied the lower Colorado River area where many geoglyphs are located. Positions along the river were not firmly fixed by the various Indian groups because of constant strife. In comparatively recent times the Halchidhoma and Kohuana were forced to flee to the Maricopa in Arizona for protection from the Mojave and Yuma. Such hostilities ended in 1857, when the Pima and Maricopa joined to defeat the Mojave and Yuma.

Ethnographic data pertaining to the geoglyphs is very meager. The Mojave Indians of the Colorado River deny having built them and disclaim any knowledge of the ancient ones who did. However, an interesting excerpt by Frank Russell about the sacred places of Pima Indians on page 254 of the *Twenty-Sixth Annual Report of the Bureau of American Ethnology* printed in 1908, may provide not only a clue as to who constructed the large geoglyphs, but also some insight about why they were created. A portion of Russell's writing is quoted as follows:

Ha-ak Va-ak Lying, is a crude outline of a human figure situated about five miles north of Sacaton. It was made by scraping aside the small stones with which the mesa is there thickly strewn to form furrows about 50 cm. wide. The body furrow is 35 m. long and has a small heap of stones at the head, another at a distance of 11 m. from the first, and another at the junction of body and legs. The latter are 11 m. long and 1 m. apart. The arms curve outward from the head and terminate in small pyramids. In all the piles of stone, which have a temporary and modern appearance, are glass beads and rags, together with fresh creosote branches, showing that the place is yet visited. The beads are very old and much weathered. Beside the large figure is a smaller one that is 4.5 m. long, the body being 2.7. Ha-ak is supposed to have slept one night at this place before reaching Ha-ak Tcia Hak, a cave in the Ta'atûkam mountains, where she remained for some time.

A brief quotation from the creation myth of the Pima Indians as related by Frank Russell explains just who Ha-ak was.

. . . when he came back she searched for the football, but it was not to be found. It had gone into her womb and become a child. When this child was born it was a strange-looking creature. The people wanted to destroy it, but the mother said it was her child and she wished to care for it.

The people wished to destroy the child because it had long claws instead of fingers and toes; its teeth were long and sharp, like those of a dog. They gave it the name of Ha-ak, meaning something dreadful or ferocious. This female child grew to maturity in three or four years' time. She ate anything she could get her hands on, either raw or cooked food. The people tried to kill her, because she killed and ate children. She went to the mountain Ta'-atûkam and lived there for a while in a cave . . .

The geoglyph near the town of Pima, Arizona, is related to the fearsome, cannibalistic creature known as Haak Vaak and is definitely connected with Pima mythology.

Much more research is required before we can under-

91

stand who constructed the many geoglyphs and why they were produced. Some insight may be obtained from a brief review of ethnographic information of ground paintings practiced by the Southern California Indians.

Ground paintings, the most fragile type of prehistoric art, have been documented by early writers of the Navajo and Pueblo peoples of the Southwest and of the Indians of Southern California. The Cocopah practiced ground painting and also employed the technique of constructing raked gravel designs. The Yuma, Cahuilla, Fernandeño, Cupeño, Juaneño, Luiseño, Diegueño, and others made some use of ground paintings. Various colors of earth pigments were used in creating the paintings.

The Yuma shamans made ground paintings, drew marks on the ground, constructed small mounds of earth, and made circles on the ground to aid in healing a man suffering from wounds.

The Fernandeño made a four-sided ground painting. The shaman stood in the middle of the design holding twelve radiating strings, with twelve assistants each holding the end of one string at the outer edge of the ground painting. When the shaman shook the strings, the ground quaked, and the enemy he wished harmed would become sick.

The Cupeño made circular ground paintings about twelve feet in diameter. Three holes were made in the center of the circle, the middle one representing the heart of the universe. On opposite sides of the circle were figures of the twin creators, Mukat and Tumaiyowit. It is believed that Mukat was on one side of the circle while Tumaiyowit was on the other side, perhaps representing good and evil influences. Each figure had a walking stick and a pipe.

For the boys' initiation ceremony, the Juaneño made a ground painting which included designs of animals. The Cahuilla made use of ground paintings for both the boys' and girls' initiation ceremonies. Red, black, and white colors were used and designs depicting the celestial bodies, animals, birds, and the world were all constructed.

The Diegueño made circular ground paintings, fifteen to eighteen feet in diameter, which depicted celestial bodies, animals, and geographical features. They also made anthropomorphic ground pictographs with cordage made from local plants.

The Luiseño employed ground paintings for both boys' and girls' initiation ceremonies. The circular ground painting for boys was divided into quarters, with a central hole from twelve to fifteen feet in diameter dug into the earth about two feet in depth. The ground paintings for girls employed concentric circles around the exterior, with designs of plants, celestial bodies, animals, and anthropomorphic designs included within the circle.

It is interesting to note the variety of designs reported for ground paintings, including anthropomorphic figures, quadruped figures and designs of crosses, circles, and spirals. All of these are easily identifiable designs of

geoglyphs, petroglyphs, and pictographs.

Because of their fragile nature, none of the ground paintings noted during early historic times exist today, but the pictographs, petroglyphs, and geoglyphs remain to arouse our interest in seeking to understand the people of the past.

For many decades, men and women have tried to understand what the prehistoric people were expressing through their various forms of rock art. The geoglyphs contain undiscovered information which when understood will enable us to glimpse the thoughts and actions of these people who lived long, long ago.

Geoglyphs have received less attention from researchers than petroglyphs or pictographs. Currently, however, much important work in this area is underway. Emma Lou Davis' work in Panamint Valley alignments, for example, is well along. Ron Smith and Daniel McCarthy have been active in Riverside County (plate 18); Jay von Werlhof, Harry Casey, and B. Johnson have concentrated on the geoglyphs of Imperial County and southwest Arizona; and several researchers of the Archaeological Survey Association of Southern California, University of Redlands, are also active.

Geoglyphs are more widespread in California and throughout the world than has been previously assumed. They were constructed by prehistoric people for ceremonial purposes which we may never fully understand or appreciate. It is important for us to realize and meet our responsibility for the preservation and further study of geoglyphs, for they are an important part of our cultural heritage.

Preservation is necessary owing to the rapid rate of destruction caused by an unaware society. Since the geoglyphs are located on the surface of the ground, they are easily destroyed by vehicles, construction, or farming activities. Even after geoglyph sites have been fenced by volunteers or the Bureau of Land Management, vandals have cut the fences and have deliberately driven vehicles over the designs. Such actions not only indicate a lack of sensitivity and a lack of knowledge, but also an alienation from the human family. Human cultural heritage belongs to all people, and the information gathered from research by scholars must be shared.

In order to protect cultural resources such as geoglyphs, measures must be taken to restrict access to some locations, provide shelters over some, and when possible transfer ownership to responsible nonprofit organizations or governmental agencies. More important, it is necessary to provide a general educational program for the public in order to develop an awareness of the responsibility we have to preserve our cultural heritage.

Gerald Smith
Redlands, California

The first were Sky and Earth, male and female, who touched far in the west, across the sea. Then was born from them Matavilya, the oldest; and all men and beings. In four strides Matavilya led them upward to Aha'-av'ulypo, in Eldorado Canyon on the Colorado, above Mojave land; the center of the earth, as he found by stretching his arms.

From a Mojave origin myth

Plate 19
Perhaps the best known and most often photographed of the geoglyphs are these two figures near Needles. Constantly threatened by vandalism, the art is protected by a chain link fence, frequently torn down in frenzied efforts at destruction.

Photo: C. William Clewlow, Jr.

The 35mm Camera and Rock Art Photography

Any number of photography books will explain the basics, a few will provide tips on composition, but none will tell you how to make a good photograph. Photography can be learned only through experience. Photography of rock art is no exception, but we will share with you a few techniques that cannot be gleaned from the basic how-to books.

If there is an art to the photography of rock art, it is that of telling a story. Study the photographs of this collection closely. What can you learn from them? Being a good photographer involves more than knowing how to use a camera: it requires knowing what to say. If you want to record the art of a culture, learn as much as possible about the culture. You'll have to learn to use the scientific tools of archaeology and anthropology to form your opinions about the art. Base your photos on the environmental setting, ethnography, archaeological remains, and parallels with the beliefs of similar cultures. Then you will be able to make photographs that educate, as well as accurately record rock art. Remember, photography is a tool; it is only as good as the photographer.

Only recently has color photography been used by students of Native American rock art. Poor color reproduction, lack of image sharpness, and an ignorance of color film storage techniques have prompted archaeologists to rely on sketches, tracings, and black-and-white photography to record rock art. Sketches and tracings can be used to record art under the most difficult of circumstances and are often used to record images that are seemingly impossible for film to capture. However, few recordings can compete with the impact of a good photograph. Black-and-white photographs are great for the study of petroglyphs (see Turner, this volume), but don't work for the study of pictographs. Black-and-white is like a body with no legs; the contribution of color makes the body whole.

We are limiting our discussion to 35mm color photography—the format we have found works best for most people. This exhibit is the first attempt at surveying the existing 35mm color photographs of California rock art from amateur and professional collections. Although professional archaeologists are becoming more actively involved in rock art study, their contributions to rock art photography have not begun to approach what is possible to do. Most of the photographers represented in this exhibit are amateurs.

Whether you are interested in rock art or archaeology, photography is the arena where amateurs can stand out. But, it takes more than weekend snapshots. You must learn to be creative when facing the variety of problems presented by rock art photography. A site may be as accessible as driving to a city park, or it may require hiking for several days through treacherous chaparral. Rock art can be located on an easily photographed cliff face or in an impossible rock cleft with barely enough room for the photographer, let alone equipment. Natural lighting can vary from the ideal to the impossible. Regardless of the problems encoun-

tered, we have found that a few simple rules for rock art color photography will help to give you better, more reliable results.

To begin, start with one essential tool: always use a tripod. Ingrain that in your memory. Camera movement contributes more to the loss of image sharpness than any other factor. Use your camera's self timer (an automatic shutter delay explained in your operator's manual) or a cable release to prevent the accidental jarring of the tripod. Any movement defeats the purpose of carrying the extra weight.

Not just any tripod will do. The legs must be sturdy, the camera platform should tilt at least 90 degrees in two directions, and it should be lightweight and compact.

Depth of field (the nearest and farthest points from the film plane in focus) rivals camera movement in its impact on image sharpness. It can only be controlled by the lens aperture (marked by f-stops) and camera distance from what you are photographing. A higher f-stop indicates a smaller aperture which increases the depth of field. The closer the camera moves to the subject, the narrower the depth of field becomes. An approximate indication of depth of field can be found using the numbers engraved on your camera's focusing ring. The ideal aperture range falls between f/11 and f/22, which usually requires exposures of one second or longer in low-light conditions. But, long exposures create a bothersome feature called reciprocity failure.

Reciprocity failure is the film's inability to form a good picture when the light is weak. It creates an oddly colored image, if an image is formed at all. In most color films, reciprocity failure becomes a problem when exposures exceed one second. Kodachrome 25 slide film (processed by Kodak) produces a fine resolution, quality color image when allowance for reciprocity has been made by increasing exposure time and using color compensating filters to adjust for color shifts.

Kodachrome 25 slides also have the advantage of an estimated life span of 50 years under proper storage conditions. Should longer storage be necessary, color separation negatives will be required. Color separations must be made, however, for all color films intended for permanent storage. Alternative archival processes or films, such as Polaroid, cannot guarantee that a photograph will survive.

For the most accurate, true-to-life results, photograph rock art by natural light. The artist painted by it. That is how the people saw it. You will have to learn how to balance light using filters and to be patient if the light is not ideal. Plan on returning to a site four or five times until you discover the suitable lighting for your work. On one occasion, we were forced to play guessing games with a storm front in order to take advantage of the diffuse lighting afforded by the cloud cover. Improvise a portable studio that will fit in a backpack. That will allow you to create lighting conditions with natural, reflected light. For impossible situations, use flash equipment.

Plate 20

Rock art photography presents unique challenges to both ingenuity and stamina. The Simi Hills pictograph site, while relatively accessible, is difficult to photograph well. The small shelter is just 4½ by 3 feet in size and contains dozens of intricate paintings, done by the Chumash. The use of a tripod and reflectors to control the lighting are a necessity. The site is thought to be part of summer solstice ritual. Photo: Mark Oliver.

Our aversion to flash photography is not a rejection of technology; rather it is a recognition of the need for moderate light and shadow to create an accurate representation of depth in a picture. In general, never apply anything to the rock surface to enhance a photograph or expose the art to any more light than is necessary. Natural light photography requires that you wait for the right light when highlights and shadows are no more than ½ stop above and below the exposure required for the main area being recorded. Any more than ½ stop and the picture quality will be of rather dubious value.

Image quality must be balanced with perspective control. Good pictures may be made with a 50mm lens, but eventually you will discover that more variation is needed to meet adverse conditions. Two more lenses will help remedy the problem and increase your camera's flexibility. A moderate telephoto, such as the 105mm, can record details with minimal telephoto distortion and only a moderate loss of depth of field. It also enables closeups of difficult-to-reach images. Wide-angle lenses, 20–24mm, have the opposite effect. They cover a broader area, making individual elements appear smaller while increasing depth of field.

Regardless of your choice of lens, the image will always be distorted unless the film plane (camera back) is kept parallel to the rock surface. Attention to this detail is an absolute must for scientific recording. At times, deliberate distortions of scale help to emphasize individual elements and their relationship to adjacent figures and natural shapes of the rock. You may find that adequate recording of a site may require distorted images, but undistorted photographs should always be made.

The human mind composes images from hundreds of visual perspectives. The photograph replaces the direct experience of seeing rock art in its natural setting. Scientific recordings often strip the life from the art by being too objective. As sites are lost to the elements or vandals, photographs become increasingly important. No single photograph can recapture the feeling of having been there. The art of photography can, however, help to preserve some of the emotions about a site. Be sure to shoot location shots which give context to the rock art itself.

In the absence of well-funded projects planned to include rock art recording, the task falls to the interested professionals and amateurs who are willing to donate their time. If you have an interest in photography, you can make a contribution to the recording of the art. Our suggestions are meant to help you overcome some common problems. But, there is no substitute for experience when photographing rock art. The only way to learn is to shoot film, a lot of film. Experiment, and keep shooting until you learn to see the finished picture before you put your eye to the camera (it's on a tripod).

William D. Hyder
Santa Barbara, California

Mark Oliver
Santa Barbara, California

References

The Joy of Photography, by Eastman Kodak Company, Addison-Wesley, 1979.

Kodak Color Films, Kodak Publication No. E-77, Eastman Kodak Company, 1977.

Kodak Filters for Scientific and Technical Uses, Kodak Publication No. B-3, Eastman Kodak Company, 1978.

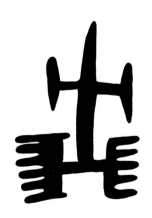

Sun's house was very big and was made of pure crystal. There were tame bears and all kinds of other animals inside.

Momoy's Grandson
Chumash Narrative

Plate 21
The brightly painted and elaborate motifs from the Simi Hills display a complexity of superimposition. The concentric circle design is found frequently in Chumash rock art, and is thought by some to be a solstice marker. Other design elements may represent mythological characters. Of particular note is a comet-like design, not visible here, which may indicate the recording of a specific astronomical event. Photo: William D. Hyder.

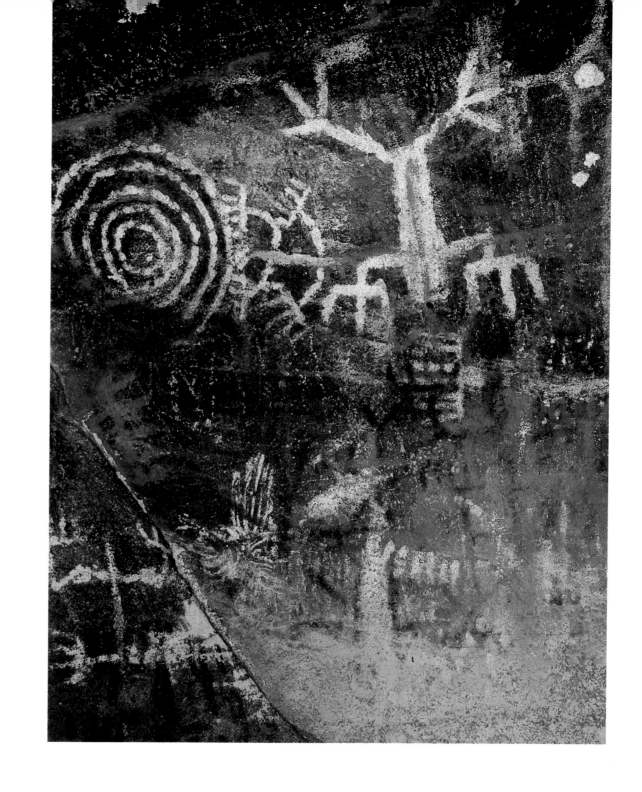

The Rock Art Archive

The Rock Art Archive, the only one of its kind in the Western Hemisphere, was established at UCLA in 1977. Under the auspices of the Institute of Archaeology and the Archaeological Survey, the Archive was made possible by a grant from the I. H. and Anna Grancell Foundation. It has been sustained by two separate grants from the Ahmanson Foundation.

The Archive has three purposes. The first and most obvious is the need to house the wide variety of privately collected and donated material dealing with prehistoric art. Secondly, the Archive exists to conduct research in the field, and to assist the efforts of other scholars, artists, and researchers. A final purpose is the dissemination of knowledge of rock art to the public at large.

Centered upon several irreplaceable collections of data, the Archive is a useful and unique resource. It has provided the data for numerous studies, publications, and analyses. Most notable among donors of material to the Archive have been Robert F. Heizer, Campbell Grant, V. L. Pontoni, Franklin Fenenga, Paul Steed, Georgia Lee, and several members of the American Rock Art Research Association.

While the Rock Art Archive takes advantage of its excellent data base for California and the western United States, it deals with rock art worldwide and is not restricted to a specific region. Significant data are on file from field work in Guatemala, Mexico, Central America, and the Guianas of South America. Some of the data are produced by external scholars, such as the published bibliography of Matthias Strecker on Central America (1979), while others of it are generated by UCLA students and scholars.

The Archive has an extensive and active public outreach program. Photographic exhibits, museum displays and programs, lectures and tours are all organized with the aim of educating the public to the need for rock art preservation. The Archive collaborates with many state and local agencies and institutions in the interest of public education, and in 1980 sponsored a conference on rock art and public programs.

All of the many programs and concerns of the Archive are supported by private funds, and field work is often undertaken by trained volunteers. Avocational interest in rock art research is encouraged and welcome, and inquiries as to how one may become involved in rock art research should be addressed to:

Rock Art Archive
Institute of Archaeology
University of California
Los Angeles, California 90024

Rock Art: Held in Trust, or Consigned to Memory?

There are an estimated 5,000 to 10,000 rock art sites in California, located throughout the state. Some are on public land, some privately owned. Some are magnificent in color and composition, others merely a casually placed element or two upon an isolated boulder. Many sites are still relatively protected by their remote locations, more are situated in areas of easy access. Hundreds have been damaged or destroyed.

Petroglyphs have been chipped from mountainsides. Whole boulders have been carried off. Paintings have been shot at with rifles. Fences have been torn down and gates demolished. Panels have been chalked and spray-painted. One could go on and on. The extent of the mindless violence visited upon rock art is shocking.

Sites once protected by their inaccessibility are now, owing to population expansion and the incessant gobbling up of land for more living space, vulnerable and quite accessible. Trails once unmarked and untraveled except by a few are now used more often by hikers whose knowledge of rock art is minimal or nonexistent. Off-road vehicles have opened up countless acres of once-solitary landscape. The urban blight of graffiti has spread to the surrounding countryside, and rock art panels are tempting targets. Ignorance in our society is highly mobile. Rock art sites in California are no longer the well-kept secret of a caring few.

The American Rock Art Research Association (ARARA), an avocational group with nationwide membership, has been instrumental in the building of public awareness about rock art. Indefatigably, the organization's leadership has sought to inform the public, influence the legislators, and shape a concerted policy of preservation. ARARA has, as well, been a significant legitimizer of rock art study, and has set high standards of involvement for its members.

Membership in the American Rock Art Research Association is open to all who profess an active interest in research and nondestructive utilization and preservation of rock art, regardless of their nationality or country of residence. Although the Association is primarily concerned with American rock art, membership is becoming international in scope, with representatives from Mexico, South America, Canada, Europe and Africa. The benefits of membership include yearly subscriptions to *La Pintura*, reduced symposia fees, and information on current publications in the field of rock art.

Most urgently, however, membership in ARARA means a concern for continuing preservation of one of the most significant elements of our shared heritage. For more information on ARARA and its educational and research programs, write:

ARARA Membership
P.O. Box 1539
El Toro, California 92630

Over the dust and clouds
the new moon rises.
Under the red leaves at the purple hill
I lift my cup and sing:
"Only the heavens and earth are eternal
and he who lives long has many sorrows,"
but I have walked in the silver night
and seen the light of the rising sun
as it entered the blue-grey world.

Song of Dust and Clouds
Vance Goodiron

Plate 22
Framed by the rising moon, the magnificent remnants of the painted cave of San Emigdiano serve as a silent but powerful reminder of ancient lifeways. Photo: Sandra Uchitel.

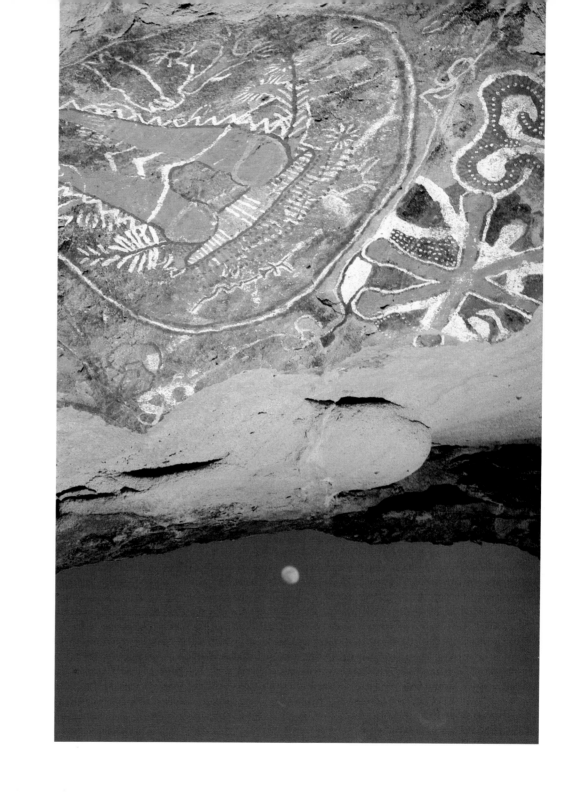

Ancient Images on Stone

**A Photographic Exhibit
Directed by Jo Anne Van Tilburg
Sponsored by the UCLA Rock Art Archive**

Contributing Photographers:

A. J. Bock
Frank Bock
C. William Clewlow, Jr.
Kathleen Conti
Bert De Gier
Alvin Grancell
Campbell Grant
Blair and Cordell Giesen
Phillip Giesen
Ken Hedges
William D. Hyder
Steve Junak
Georgia Lee
Clement W. Meighan
Helen Michaelis
Bob Norris
Mark Oliver
Kay Sanger
Gerald Smith
Richard Quist
Sandra Uchitel
Jo Anne Van Tilburg

Endorsements:

American Indian Studies Center, UCLA
American Rock Art Research Association
Folklife Center, Library of Congress
National Park Service
State Office of Historic Preservation

Exhibitions

Cohen and Ziskin, Attorneys, Century City
Western Federal Savings, Encino
Western Federal Savings, Hollywood
Faculty Center, UCLA
Ventura City Hall
Ventura County Museum
State Office of Historic Preservation 1981 Conference
San Bernardino County Museum
All Indian Nations Art Fair, San Francisco
National Park Service, San Francisco
Carlsberg Corporation, Santa Monica
University of California, Irvine
California State University, Long Beach
Los Angeles Children's Museum

Benefactors:

Richard and Barbara Carlsberg, Carlsberg Corporation
Cohen and Ziskin, Attorneys
CD Communities, Ray Rutter
David and Valerie Doremus, Eastern Pacific
Rick Doremus, Epac Development
Bert and Kayla Given
Warner Hodgdon
Ann and Tom Lockie
Isaac D. and Ruth G. Sinaiko Foundation
Johannes Van Tilburg and Partners
Mr. and Mrs. Maurice Stans
Mr. and Mrs. C. Van Tilburg

Contributors:

Mrs. Ada T. Brownell
Mr. and Mrs. Alfred J. Dietsch
Marty Gonzales
David Hale
James Heaton III
Pat and Dick Kieckler
Steve Lebowitz
E. W. Moulton
David and Lisa O'Connor
Roger and Naomi Presburger
Paul and Suzanne Rubenstein
Pat and Victor Siegel
Claudette Y. Wittenberg
Herb Briscoe
Bob Weekley
Larry Stamen

**Shamans' Songs
The Rock Art of Western America**

**A Photographic Exhibit
Directed by Jo Anne Van Tilburg
Sponsored by the National Park Service**

Contributing Photographers:

Frank Bock
Ken Hedges
William D. Hyder
Mark Oliver

The exhibit will tour National Park Service Visitors' Centers for the coming three years. Production of the exhibit was supervised by David C. Ochsner, Cultural Resources Management, National Park Service (Santa Monica Mountains National Recreation Area), and Susan J. Cadwallader, NPS Design Center, Harper's Ferry, West Virginia. Information on exhibit scheduling may be obtained by writing the National Park Service.

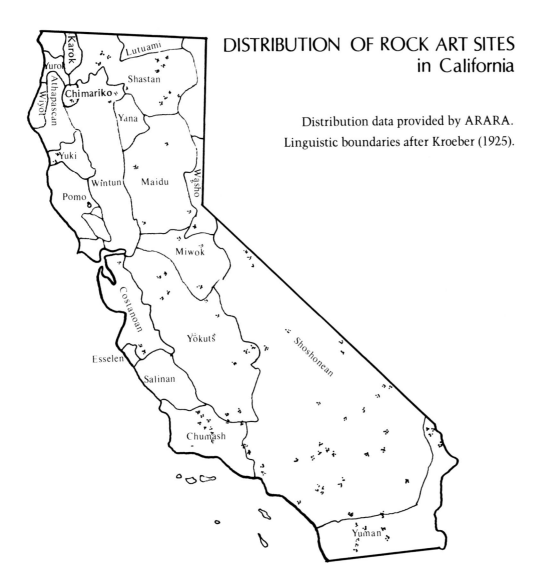

DISTRIBUTION OF ROCK ART SITES
in California

Distribution data provided by ARARA.

Linguistic boundaries after Kroeber (1925).

Karok

Lutuami

Yurok

Shastan

Athapascan

Chimariko

Wiyot

Yana

Yuki

Washo

Wintun

Maidu

Pomo

Miwok

Costanoan

Yokuts

Shoshonean

Esselen

Salinan

Chumash

Yuman

Note: One dot may indicate several sites, and new sites are regularly being recorded.

United States Senate
WASHINGTON, D.C. 20510

March 17, 1982

Ms. JoAnne Van Tilburg
University of California, Los Angeles
Rock Art Archive
The Institute of Archaeology
Los Angeles, California 90024

Dear JoAnne,

My congratulations to UCLA's Rock Art Archive for assembling for
national exhibition this catalogue and fine collection of photo-
graphs of California's rock art.

The thousands of pictographs and petroglyphs left to us by early
Californians are among the most beautiful and interesting in the
world. Sadly, the ravages of time, public insensitivity and the
lack of adequate protection have brought irreparable harm to all
but a few sites. In too many circumstances photographs are all
that remain of the art of these ancient and often unknown people.

My legislation which created the Channel Islands National Park,
the Santa Monica Mountains National Recreation Area and the more
recent Archeological Resources Protection Act are the beginning
of what I hope will become a more consistent and enlightened
federal policy for the protection and preservation of this ancient
art form.

I sincerely hope this catalogue and the traveling exhibit will help
raise the level of public concern for this neglected national
treasure and will inspire elevating the study of rock art from
an avocational effort by dedicated amateurs and Indian descendents
to a more exact discipline.

With best wishes,

Cordially,

Alan Cranston

111

Authors

Frank Bock

Dr. Frank Bock is a founder and charter member of the American Rock Art Research Association (ARARA), 1974. He has spent fourteen summers living on Hopi and Navajo Reservations, and received his Ph.D. from the University of Southern California with a dissertation focusing on the dramatic function and significance of the clown during Hopi Indian public ceremonies. Currently, he is a professor of anthropology and theatre arts at Cerritos College. He is founder and editor of *La Pintura*, the quarterly newsletter of ARARA, and writes and lectures extensively on behalf of rock art preservation. Dr. Bock has made a commitment to public education through the production of numerous educational aids, filmstrips, and video tapes dealing with the urgency of preservation of all archaeological sites.

Ken Hedges

Ken Hedges is curator of ethnology and archaeology at the San Diego Museum of Man and president of the American Rock Art Research Association. He is active in all aspects of rock art research, and has a special interest in shamanism as a possible interpretive tool in studying rock art symbology. He has personally located and recorded numerous rock art sites in the San Diego area and Baja, including the important site of La Rumarosa. His expertise in public education and mu-

seum work has been put to extensive use on behalf of rock art, and he has organized and facilitated numerous tours, lectures and exhibits. He is widely published, and recently authored "Winter Solstice Observatory Sites in Kumeyaay Territory, San Diego County, California," appearing in *Archaeoastronomy in the Americas*, edited by Ray A. Williamson.

William D. Hyder

William D. Hyder administers the Political Institutions Simulation Laboratory at the University of California, Santa Barbara. In addition to teaching, he is a consultant on the use of statistics and computers in political science and is frequently called upon to assist in the design of innovative approaches to education in the field. His interest in California rock art has taken him on extensive photographic forays throughout the state, with special emphasis on the spectacular polychromes of the Chumash.

E. C. Krupp

Dr. E. C. Krupp is an astronomer and director of Griffith Observatory in Los Angeles. After graduating from Pomona College in Claremont, California, he attended graduate school at UCLA and investigated the properties of rich clusters of galaxies. Since 1972, he has been actively involved in the study of ancient and prehistoric astronomy and is the editor and major contributor to *In Search of Ancient Astronomies* (Doubleday, 1978). His new book, *Echoes of the Ancient Skies*, will be published by Harper and Row in February, 1983. He

has visited and examined more than 300 archaeological sites in Britain, Ireland, Brittany, Malta, Egypt, Mexico, Central America, Peru, the People's Republic of China, and throughout the United States, including darkest Southern California.

Frank LaPena

Frank LaPena was born in San Francisco of Asian and American Indian parents. A painter, photographer, writer, and sculptor, he is presently the director of Native American Studies at California State University, Sacramento, where he is also an associate professor of art. LaPena has authored (under his Wintu Tribal name, Tauhindauli) two poetry collections, *The Gift of Singing* and *Susuna Stopped the Rain.* His work is in several anthologies, including *CALFIA: The California Poetry,* and his "Wintu" article appeared in the Smithsonian's *Handbook of North American Indians, Volume 8; California.* Most recently he was published in *The Legends of Yosemite Miwok.* His art works have appeared in many shows and galleries in the United States, Europe, Cuba, and South America. He is active as a lecturer on American Indian art and California traditions and culture. He is also involved in traditional tribal activities as a "singer" and "dancer."

Georgia Lee

Georgia Lee is an archaeologist and art historian specializing in rock art research and documentation. A graduate of California College of Arts and Crafts and the University of California, Santa Barbara, Ms. Lee has written numerous articles and has recently authored a book on the effigies and decorated artifacts of the Chumash Indians of California, *The Portable Cosmos.* She is a research associate of UCLA's Institute of Archaeology and vice president of the American Rock Art Research Association, as well as a member of both the Society for American Archaeology and the Western Association of Art Conservators. Currently a doctoral student at UCLA, Georgia Lee is doing her field work on Easter Island. Under the auspices of the University of Chile, she is researching and documenting all of the over 1,000 rock art sites on the island. A skilled artist, Georgia's tracings of rock art designs are valuable documentation and an important part of Archive records.

Clement W. Meighan

Dr. Clement W. Meighan is a professor of anthropology at UCLA and director of the UCLA Archaeological Survey. His distinguished career has taken him throughout California and far afield, including Baja California and Central America. He has lectured and taught widely and published prolifically. Among the wide variety of books and articles he has authored, edited and coauthored are *Seven Rock Art Sites in Baja California* with V. L. Pontoni, and the recent *Messages from the Past.* His interest in art led him to contribute to *Sculpture of Ancient West Mexico,* a catalog of the Proctor Stafford Collection published by the Los Angeles County Museum of Art. The exquisite collector's volume *Indian Art and History: The Testimony of Prehispanic Rock Paintings in Baja California* was published in 1969, and details his work with the Erle Stanley Gardner expedition to the impressive painted

caves of that remote peninsula. As supervisor of the activities of the UCLA Rock Art Archive, he has been responsible for important work in encouraging rock art researchers and increasing professionalism in the field.

Mark Oliver

Mark Oliver is an art director, graphic designer, and photographer, a graduate in Fine Arts of the University of California, Irvine. He is a member of the American Rock Art Research Association and has a special interest in photographing the Chumash rock art of the Santa Barbara area. His most recent work has been with Georgia Lee's Easter Island Project.

Gerald A. Smith

Dr. Gerald A. Smith is founder and director of the San Bernardino County Museum. A graduate of the University of Redlands, he has done graduate work at UCLA and Harvard School of Business Administration, earning his Ed.D. degree at the University of Southern California. Dr. Smith has maintained an interest in education, archaeology, and history throughout his career. He has worked with the Micronesian people of the Marshall Islands, and assisted the late Dr. M. R. Harrington in field archaeology in northern and Southern California. Dr. Smith has written numerous books and articles dealing with the history and prehistory of the Mojave and Serrano Indians of southern California, and established files for the ever-increasing records of archaeological sites discovered in southern California. A past president of the Conference of California Historical Societies, he was presented a Special Award for outstanding effort in preserving state and local history.

Wilson G. Turner

Wilson G. Turner is a graduate of the Chouinard Art Institute. As a native Californian, he has a long-standing interest in the state's history and cultural heritage, particularly its legacy of rock art. For over twenty years he has pursued this interest in the mountains and deserts of Southern California, recording, drawing, and photographing numerous rock art sites. He is the director of the Black Canyon Petroglyph Project of the Mojave Desert, sponsored and supported by Earthwatch. Illustrated reports of this extensive recording project have been published in the *San Bernardino County Museum Quarterly*. With Gerald A. Smith, he has written *Indian Rock Art of Southern California*, a volume including his "Selected Petroglyph Catalog." He is an indefatigable champion of rock art preservation and has employed his expertise as both a teacher and an artist in his labors on behalf of rock art research. He is an active member of ARARA, and continues to puruse a wide range of interests, including Maya hieroglyphic investigations, dating petroglyphs, and the development of standardized field recording methods.

Glossary

Descriptive terminology for rock art is often subjective, repetitive, overlapping, and confusing. Rather than use conflicting terms, it is better to use precise, objective, physical descriptions. Problems arise often, for what is "abstract" to one person is "stylized" to another and "representational" to a third. One picture is better than a lengthy description; thus a careful sketch or good photograph will be of more ultimate value than a misleading or misinterpreted description.

The following glossary was compiled by Georgia Lee after careful consideration and with input from numerous colleagues. It lists some basic rock art terms often found in the literature. Some understanding of these terms and consistency in their use will be helpful in the pursuit of rock art research. Drawings are by Kathleen Conti.

Abrading	Utilization of an abrasive tool or substance to wear away portions of the rock surface.
Abstract	Nonrepresentational; emphasis on generalized or geometrical forms.

Amorphous	No particular shape; lacking definite form.
Anthropomorphic	Having human form or attributes.

Bas Relief	Figures that project slightly from the background; also called low relief.
Bruising	Pounded upon, lightly chipped by use of a hammerstone.
Conventionalized	Represented in a generalized or simplified manner.

115

Curvilinear	Made up of curved lines.

Cupules	Small, shallow pits chipped and/or abraded into the surface of the rock. Usually found in multiples, these are (apparently) randomly placed, or may form patterns. Found on both vertical and horizontal surfaces. Some oval shaped cupules have been recorded.
Desert Varnish	The dark patinated surface of a rock.
Design	The pattern or motif of artistic work.
Element	Any definable figure.
Exfoliation	To come off in scales or flakes; natural weathering.

Form	Shape or configuration.
Geoglyph	Ground figure made by removal of surface gravels to expose the lighter soil beneath.
Geometric	Orderly, regular lines or figures.

Groove	A long narrow cut or indentation in a surface, either pecked or incised.
Incised	Cut or grooved with a sharp tool.
Intaglio	A figure or design sunk below the surface, often used to describe ground figures. Replaced by *geoglyph* in current usage.

Motif	Major theme, or repeatedly used design.
Naturalistic	Realistic or recognizable.

Nonobjective	Pattern, color, and/or design, with no identifiable subject.
Nonrepresentational	Not recognizable to the comtemporary observer (but may have represented something to the aboriginal artist).

Panel	A group of elements in a defined space.

Patina	Surface alteration of rock caused by chemical reactions to heat and moisture (desert varnish).
Pecking	Striking the surface of the rock with a hammerstone directly, or using a hammer to drive a chisel into the rock to remove small masses of material. In a petroglyph, pecking is often the first step, with the design being finished by abrasion.
Petroglyph	Carving made on stone by pecking, carving, abrading, scratching, or bruising, or by any combination of these techniques.

Pictograph	Rock painting.
Pit and Groove	A particular style of rock art defined in western Nevada which consists of cupules and wide, pecked grooves.

117

Quadruped — Four-legged animal, not identifiable as to particular type or species.

Rectilinear — Made up of straight lines or groups of straight lines.

Representational — Depicted in a recognizable manner. We can assume that all rock art is representational in that the aboriginal artist was representing something in his/her experience, but the term is generally used to indicate something recognized by the contemporary observer.

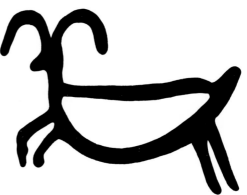

Realistic — More lifelike or representational than stylized or abstracted. To be truly realistic is to be photographically accurate. Thus, technically, all native rock art designs are stylized to some degree.

Rock Alignment — Rocks placed or arranged so they form designs or configurations.

Rock art	Any design made on stone surfaces by humankind.	Type	Specific form and characteristic mode of expression of any element.
Schematic	Reduced to basics, as in a map or diagram. A schematic design conveys meaning but reduced to minimal detail.	Zoomorph	Having animal form or attributes.

Style — Consistent form, and/or repetitive design elements in the art of a group or individual. Also, overall aesthetic quality.

Symbol — Something used for, or regarded as, representing something else.

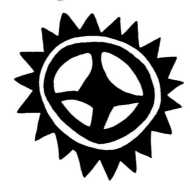

Stylized — Identifiable, made in such a way that it more or less suggests a specific form; conventionalized but recognizable.

119

Epigraphs accompanying photographic plates are quoted from the following sources:

Plates 3, 4. *Breath of the Sun*, edited by Travis Hudson. Malki Museum Press, 1979, p. 38.

Plate 5. *Handbook of the Indians of California*, by A. L. Kroeber. Bulletin 78, Bureau of American Ethnology, Smithsonian Institution, 1925, p. 509.

Plate 6. "Hands," from *The Selected Poetry of Robinson Jeffers*, © by Random House, reprinted by permission of the publisher and the estate of Robinson Jeffers.

Plate 7. *Akwasasne Notes*, Vol. 5, no. 5 (Autumn) 1973, p. 34. Reprinted with permission of the publisher.

Plate 8. *Bigfoot and Other Stories*, by Elizabeth B. Johnstone. Tulare County Board of Education, 1975, p. 34. Reprinted by permission of the publisher.

Plate 9. *Crystals in the Sky: An Intellectual Odyssey Involving Chumash Astronomy, Cosmology and Rock Art*, by Travis Hudson and Ernest Underhay. ©1978 by Ballena Press/Santa Barbara Museum. Reprinted by permission of the author.

Plate 10. *December's Child, A Book of Chumash Oral Narratives*. Thomas Blackburn, ed. University of California Press, © 1975. Narrative 60, "The Slighted Princess," p. 252. Reprinted with permission.

Plate 11. *December's Child*, Narrative 11, "Reincarnation," p. 98. Reprinted with permission.

Plate 12. *Handbook of the Indians of California*, p. 685.

Plate 13. *December's Child*, Narrative 10, "The Soul," p. 97. Reprinted with permission.

Plate 14. "Flower and Song," by Miguel Leon Portilla. In *The Mexicans through their Chronicles and their Epics*. Reprinted in *Arte Prehispánico de México, Collección Rufino Tamayo*. Ediciones Galeria de Arte Misrachi, Mexico, 1973, p. 3. Translation of Spanish quoted:

Only the god
listens here anymore,
he has descended from the inside of heaven,
he comes singing.

Plate 15. *Handbook of the Indians of California*, p. 194.

Plate 16. "An Artist," by Robinson Jeffers.

Plate 17. *Almost Ancestors*, by Theodora Kroeber and Robert F. Heizer. Sierra Club, 1955, p. 68.

Plate 18. *Handbook of the Indians of California*, p. 776.

Plate 19. *Handbook of the Indians of California*, p. 770.

Plate 21. *December's Child*, Narrative 18, "Momy's Grandson," p. 131. Reprinted with permission.

Plate 22. *The Indian Historian*, Vol. 3, no. 2 (Spring) 1970, p. 48. Reprinted with permission.

Color Plates

1. Coso Range, Inyo County; Fall, 1979; Jo Anne Van Tilburg; Nikon; 50mm; Kodachrome 64.
2. Painted Cave, Santa Barbara County; Fall, 1979; Mark Oliver; Nikon; 20mm; Kodachrome 25.
3. Sycamore Creek, Los Angeles County; Spring, 1982; David C. Ochsner; Hasselblad; Ektachrome 64.
4. Zuma Ridge, Los Angeles County; Spring, 1982; David C. Ochsner; Hasselblad; Ektachrome 64.
5. Arrowhead Springs, Santa Barbara County; Winter, 1980; William D. Hyder; Nikon; 20mm; Kodachrome 25.
6. Church Creek, Monterey County; Fall, 1977; Kathleen Conti; Minolta; 55mm; Kodachrome 64.
7. Porterville, Tulare County; Spring, 1982; William D. Hyder; Nikon; 24mm; Kodachrome 25.
8. Tule Indian Reservation, Tulare County; Spring, 1982; William D. Hyder; Nikon; 24mm; Kodachrome 25.
9. Montgomery Portrero, Santa Barbara County; Winter, 1981; Tom Hoskinson; Rolleiflex; 35mm; Ektachrome 400.
10. Simi Hills, Ventura County; Winter, 1982; William D. Hyder; Nikon; 50mm; Kodachrome 25.
11. Edgar Rock, San Luis Obispo County; Winter, 1979; Mark Oliver; Nikon; 20mm; Kodachrome 25.
12. Wikwip, San Diego County; Spring, 1975; Ken Hedges; Canon; 50mm; Agfachrome 64.
13. San Emigdiano, Kern County; 1978; Sandra Uchitel; Nikon; 18mm; Kodachrome 25.
14. Gardner Cave, Face C, Baja California; 1964; Clement W. Meighan.
15. Coso Range, Inyo County; Fall, 1979; Phillip A. Giesen; Nikon; 50mm; Kodachrome 64.
16. Coso Range, Inyo County; Fall, 1976; Kathleen Conti; Minolta; 55mm; Kodachrome 64.
17. Elledge Valley, Mendocino County; Spring, 1982; Ken Hedges; Canon; 50mm; Fugichrome 100.
18. Geoglyph, Riverside County; Fall, 1980; Ron Smith.
19. Geoglyph, Riverside County; C. William Clewlow, Jr.
20. Simi Hills, Ventura County; Winter, 1982; Mark Oliver; Nikon; 20mm; Kodachrome 25.
21. Simi Hills, Ventura County; Spring, 1981; William D. Hyder; Nikon; 24mm; Kodachrome 25.
22. San Emigdiano, Kern County; 1978; Sandra Uchitel; Nikon; 18mm; Kodachrome 25.

Bibliography

Applegate, Richard
 1978 'Atishwin: The Dream Helper in South-Central California. Socorro: Ballena Press Anthropological Papers 13.

Arnold, H. H.
 1932 Who Drew These Giants Along the Colorado? Touring Topics, November, 1932.

Baumhoff, M. A., R. F. Heizer, and A. B. Elsasser
 1958 The Lagomarsino Petroglyph Group (Site 26-St-1) Near Virginia City, Nevada. Reports of the University of California Archaeological Survey, No. 43, Part II. Berkeley.

Bean, Lowell John, and Sylvia Brakke Vane
 1978 Shamanism: An Introduction. In Art of the Huichol Indians, ed. Kathleen Berrin, pp. 118–128. New York: Harry N. Abrams, Inc.

Belden, L. Burr
 1952 Momyer Offers Solution to Riddle of Pictographs. San Bernardino Sun-Telegram, December 7, 1952.

Blackburn, Thomas
 1975 December's Child: A Book of Chumash Oral Narratives. Berkeley: University of California Press.

 1977 Biopsychological Aspects of Chumash Rock Art. Journal of California Anthropology 4(1): 88–93.

Boas, Franz
 1955 Primitive Art. Toronto: Dover Publications, Inc.

Bock, Frank G.
 1969 A Visit to Big and Little Petroglyph Canyons. San Bernardino County Museum Quarterly 16(3): 1–7.

Bock, Frank G., and Alice J. Bock
 1974 Western Petroglyphs: Petroglyphs and Pictographs of the Western United States. (Slides with guide). Kai-Dib Films International, Glendale, California.

Breuil, H.
 1952 Four Hundred Centuries of Cave Art, English edition. Montignae.

Clewlow, C. William, Jr.
 1978 Prehistoric Rock Art. In Handbook of North American Indians, Vol. 8: California, ed. Robert F. Heizer, pp. 619–625. Washington: Smithsonian Institution.

Coe, Ralph T.
 1976 Sacred Circles: Two Thousand Years of North American Indian Art. United Kingdom: Arts Council of Great Britain.

Crosby, Harry
 1975 The Cave Paintings of Baja California. San Diego: Copley Press.

Davis, John V., and Kay S. Toness
 1974 A Rock Art Inventory at Hueco Tanks State Park, Texas. El Paso Archaeology Society, Inc. Special Report No. 12.

DuBois, Constance Goddard
 1908 The Religion of the Luiseño Indians of Southern California. University of California Publications in American Archaeology and Ethnology 8(3): 167–173.

Drucker, Philip
 1937 Southern California, Culture Element Distributions: 5. Anthropological Records 1(1).

1941 Yuman-Piman, Culture Element Distribution: 17. *Anthropological Records* 6(3).

Eliade, Mircea
1964 *Shamanism: Archaic Techniques of Ecstasy.* Bollingen Series LXXVI. Princeton: Princeton University Press.

Emerson, Lee
1971 Petroglyphs of Ancient Man. *Indian Historian*, Spring, 1971.

Furst, Peter T., ed.
1972 *Flesh of the Gods: The Ritual Use of Hallucinogens.* New York: Praeger Publishers.

Furst, Peter T.
1974 Roots and Continuities. In *Stones, Bones & Skin: Ritual and Shamanic Art. Artscanada* 30(5 & 6): 33–60.

1976 *Hallucinogens and Culture.* San Francisco: Chandler and Sharp Publishers, Inc.

Getze, George
1965 Giant Desert Figures May Show Prehistoric Concern Over Water. *Los Angeles Times*, June 6, 1965.

Giedion, S.
1902 *The Eternal Present: The Beginnings of Art.* New York: Pantheon Books.

Gifford, E. W.
1933 The Cocopa. *University of California Publication in American Archaeology and Ethnology* 31(5): 257–334.

Grant, Campbell
1965 *The Rock Paintings of the Chumash.* Berkeley: University of California Press.

1974 *The Rock Art of Baja California.* Baja California Travel Series, No. 33. Los Angeles: Dawson's Book Shop.

1981 *Rock Art of the American Indian.* Colorado: Outbooks.

Grant, Campbell, James F. Baird, and J. Kenneth Pringle
1968 *Rock Drawings of the Coso Range, Inyo County, California.* Publication No. 4, Maturango Museum, China Lake, California.

Haenszel, Arda
1971 Archaeological Survey Association of Southern California *Newsletter.* Vol. 19, No. 2.

1978 The Topock Maze: Commercial or Aboriginal? *Quarterly of the San Bernardino County Museum Association*, vol. 26, no. 1.

1980 History in Black Canyon. In *A History of Black Canyon*, ed. Charley Howe. Archaeological Association of Southern California, affiliated with The University of Redlands.

Hambleton, Enrique
1979 *La Pintura Rupestre de Baja California.* Fomento Cultural Banamex. Mexico, D.F.

Harmer, Michael J.
1953 *Gravel Pictographs of the Lower Colorado River Region.* University of California Archaeological Survey Report, No. 20. Berkeley.

Hedges, Ken
1976 Southern California Rock Art as Shamanic Art. In *American Indian Rock Art, Volume 2: Papers presented at the Second Annual Rock Art Symposium*, ed. Kay Sutherland. El Paso: El Paso Archaeological Society, Inc.

1981 Great Basin Rock Art Styles: A Revisionist View. Paper presented at the Eighth Annual Rock Art Symposium, Winnipeg, Manitoba, Canada.

Heizer, Robert F., and Martin A. Baumhoff
1962 *Prehistoric Rock Art of Nevada and Eastern California.* Berkeley: University of California Press.

Heizer, Robert F., and C. W. Clewlow, Jr.
1973 *Prehistoric Rock Art of California.* Socorro: Ballena Press.

Heizer, Robert F., and Albert B. Elssaser
1980 *The Natural World of the California Indians.* Berkeley: University of California Press.

Henderson, Randall
1957 Giant Desert Figures Have Been Restored. *Desert Magazine,* November, 1957.

Hidy, Linda
1971 Harper Dry Lake. *San Bernardino County Museum Quarterly,* vol. 19, no. 2.

Hilldebrand, Timothy
1974 The Baird Site. *Monograph* 1, Maturango Museum, China Lake, California.

Hobson, Geary, ed.
1979 *The Remembered Earth: An Anthology of Contemporary Native American Literature.* Albuquerque, N.M.: Red Earth Press.

Hopa, Pare
1980 Ethnographic Overview of the Western Mojave Planning Units. In *An Overview of the Cultural Resources of the Western Mojave Planning Units,* ed. Stickland et al. BLM Cultural Resources Publications.

Houmann, Oscar
1936 Giant Desert Figures Near Blythe, registered landmark number 101. California Historical Landmarks Series, Division of Parks, Department of Natural Resources, State of California.

Hudson, Travis
1982 California's First Astronomers. In *Archaeoastronomy and the Roots of Science,* ed. E. C. Krupp. Washington, D.C.: The American Association for the Advancement of Science.

Hudson, Travis, and John Carlson, eds.
1982 *Visions of the Sky.* Ramona, California: Acoma Books and the Center for Archaeoastronomy.

Hudson, Travis, and Georgia Lee
1981 Funktion und zweck der Chumash-Felskunst. Ethnonogia Americana 18/1, Nr. 99; p. 1001–1003.

Hudson, Travis, Georgia Lee, and Ken Hedges
1979 Solstice Observers and Observatories in Native California. *Journal of California and Great Basin Anthropology,* vol. 1, pp. 38–63.

Hudson, Travis, and Ernest Underhay
1978 *Crystals in the Sky: An Intellectual Odyssey Involving Chumash Astronomy, Cosmology and Rock Art.* Socorro: Ballena Press Anthropological Papers 10.

Hunt, J. MCV.
1961 *Intelligence and Experience.* New York: Ronald Press.

Kaye, Minton W.
1932 Was There an Advanced Culture in the Southwest? *Air Corps Newsletter,* October 18, 1932.

Kirkland, Forrest, and W. W. Newcomb, Jr.
 1967 *The Rock Art of Texas Indians*. Austin: University of Texas Press.

Knoll, M., J. Kugler, O. Hofer, and S. D. Lawder
 1963 Effects of Chemical Stimulation of Electrically-Induced Phosphenes on their Bandwidth, Shape, Number and Intensity. *Confinia Neurologica* 23: 201–226.

Kroeber, A. L.
 1976 *Handbook of the Indians of California*. New York: Dover Publications.

Krupp, E. C.
 1982 *Echoes of the Ancient Skies*. New York: Harper & Row, Publishers.

Krupp, E. C., ed.
 1978 *In Search of Ancient Astronomies*. Garden City, New York: Doubleday & Company, Inc.

Lee, Georgia
 1977 Chumash Mythology in Paint and Stone. *Pacific Coast Archaeological Society Quarterly* 13 (3): 1–14.

 1979 The San Emigdio Site. *Journal of California and Great Basin Anthropology* 1 (2): 295–305.

 1981 *The Portable Cosmos: Effigies, Ornaments, and Incised Stone from the Chumash Area*. Socorro: Ballena Press Anthropological Papers 21.

Lee, Georgia, and Stephen Horne
 1978 The Painted Rock Site (SBa 502–526): Sapaksi: The House of the Sun. *Journal of California Anthropology* 5 (2): 216–224.

Lommel, Andreas
 1967 *Shamanism: The Beginnings of Art*. New York: McGraw Hill.

Mallery, G.
 1885 Account of Yuma Ceremonies. *Smithsonian Miscellaneous Collections*, vol. 34, pp. 143–144.

Mc Gowan, Charlotte
 1978 Female Fertility Themes in Rock Art, *Journal of New World Archaeology* 2 (4). University of California, Los Angeles.

Mead, Margaret
 1932 An Investigation of the Thought of Primitive Children with Special Reference to Animism. *Journal of the Royal Anthropological Institute of Great Britain and Ireland*, pp. 173–190.

Meighan, Clement W.
 1969 *Indian Art and History*. Baja California Travel Series, no. 13. Los Angeles: Dawson's Book Shop.

 1982 Theory and Practice in the Study of Rock Art. In *Messages of the Past*, ed. C. W. Meighan. UCLA Institute of Archaeology Monograph XX. Los Angeles.

Michael Heizer
 1979 Museum Folkwang Essen and Rijksmuseum Kröller-Müller. Otterlo, The Netherlands.

Minor, Rick
 1973 Known Origins of Rock Paintings of Southern California. *Pacific Coast Archaeological Society Quarterly* 9(4): 29–36.

Moulin, Raoul-Jean
 1965 *Prehistoric Painting*. New York: Funk & Wagnalls.

Myron, Robert
1964 *Prehistoric Art*. New York: Pitman Publishing Corp.

Neatum, Duane, ed.
1975 *Carriers of the Dream Wheel: Contemporary Native American Poetry*. New York: Harper & Row.

Oster, Gerald
1970 Phosphenes. *Scientific American* 222:83–87.

Pager, Harald
1975 *Stone Age Myth and Magic*. Graz, Austria: Akademische Druck-u. Verlagsanstalt.

Panlaqui, Carol
1974 The Ray Cave Site. *Monograph No. 1*, Maturango Museum, China Lake, California.

Piaget, J.
1950 *The Psychology of Intelligence*. London: Routledge and Kegan Paul.

Reichel-Dolmatoff, Gerardo
1971 *Amazonian Cosmos: The Sexual and Religious Symbolism of the Tukano Indians*. Chicago: University of Chicago Press.

1978 *Beyond the Milky Way: Hallucinatory Imagery of the Tukano Indians*. Los Angeles: UCLA Latin American Center Publications.

Rogers, M. J.
1939 Early Lithic Industries of the Lower Basin of the Colorado River and Adjacent Areas. *San Diego Museum Paper* No. 3.

Rogers, Malcolm J.
1966 *Ancient Hunters of the Far West*.

Rose, Wendy
1980 *Lost Copper*. Banning, California: Malki Museum Press.

Russell, Frank
1908 The Pima Indians. *Annual Report of the Bureau of American Ethnology* 26: 3–390. Washington, D.C.: Government Printing Office.

Schaller, George B.
1980 *Stones of Silence*. New York: Viking Press.

Schultes, Richard Evans
1972 An Overview of Hallucinogens in the Western Hemisphere. In *Flesh of the Gods*, ed. Peter T. Furst, pp. 3–54.

Schultes, Richard Evans, and Albert Hoffman
1979 *Plants of the Gods: Origins of Hallucinogenic Use*. New York: McGraw-Hill Book Company.

Smith, Gerald A., and Wilson G. Turner
1975 *Indian Rock Art of Southern California*. San Bernardino County Museum Association. Redlands, California.

Sparkman, P. S.
1908 Culture of the Luiseño Indians. *University of California Publications in American Archaeology and Ethnology*, vol. 8, pp. 187–234.

Swarthout, Jeanne, and Christopher E. Drover
1981 Final Report for an Archaeological Overview for the Lower Colorado River Valley, Arizona, Nevada, and California; REACH 3, Davis Dam to the International Border. Report prepared by the Museum of Northern Arizona for the Bureau of Reclamation.

Trupe, Beverly S., John M. Rafter, and Wilson G. Turner
 1980 Ring of Pictured Stones: Astronomical Connotations of a Rock Art Site in the Eastern Mojave Desert. Preliminary unpublished report, August, 1980.

Turner, Wilson G., and Robert Reynolds
 1977 Dating the Salton Sea Petroglyphs. *Science News,* vol. 111, no. 9.

Van Tilburg, Jo Anne, and Clement W. Meighan
 1981 *Prehistoric Indian Art: Issues and Concerns,* Monograph XIX, UCLA Institute of Archaeology. Los Angeles.

Vastokas, Joan M.
 1974 Shamanic Tree of Life. In *Stones, Bones & Skin: Ritual and Shamanic Art. Artscanada* 30(5–6).

Vastokas, Joan M., and Romas K. Vastokas
 1973 *Sacred Art of the Algonkians: A Study of the Peterborough Petroglyphs.* Peterborough, Ontario: Mansard Press.

Wasson, M. Gordon
 1971 *Soma: Divine Mushroom of Immortality.* New York: Harcourt Brace Jovanovich.

Weisbrod, R.
 1978 Dating Technique Proposed for Petroglyphs. *Science News,* vol. 11, no. 4.

Wellman, Klaus, M.D.
 1977 *A Survey of North American Indian Rock Art.* Akademishe Druck-u. Verlagsanstalt, Austria.

Williams, Anita Alvarez
 1976 Five Rock Art Sites in Baja California South of the 19th Parallel. *Pacific Coast Archaeological Society Quarterly* 9(4):37–46.

Williamson, Ray, ed.
 1981 *Archaeoastronomy in the Americas.* Los Altos, California: Ballena Press and the Center for Archaeoastronomy.

Williamson, Robert Stockton
 1856 U.S. Congress, House, Reports of Explorations and Surveys, to Ascertain the Most Practicable and Economical Route for a Railroad from the Mississippi River to the Pacific Ocean. *House Exec. Doc. 91, 33* Cong., 2d. Sess., Vol. V, Washington, D.C.: Government Printing Office.

Woodward, Arthur
 1932 Gigantic Intaglios in the California Desert. *Illustrated London News,* September 10, 1932.

Bibliography for Teachers and Young People

Balls, E. K.
 1962 *Early Uses of California Plants*. Berkeley: University of California Press.

Cornell, James
 1981 *The First Stargazers*. New York: Charles Scribner's Sons, Inc.

Faber, G., and M. Lasagna
 1980 *Whispers from the First Californians*. Alamo, Calif.: Magpie Press.

Jeffers, Robinson
 1965 *Selected Poems*. New York: Vintage Books.

Johnstone, E. B.
 1975 *Bigfoot and Other Stories*. Visalia, Calif.: Tulare County Board of Education.

Krupp, E. C.
 1979 *Ancient Watchers of the Sky*. 1980 Science Year. Chicago: World Book-Childcraft International, Inc.

Krupp, E. C., ed.
 1978 *In Search of Ancient Astronomies*. New York: McGraw-Hill Book Co.

Lopez, Raul A., and Christopher L. Moser, eds.
 1981 *Rods, Bundles and Stitches: A Century of Southern California Indian Basketry*. Riverside, Calif.: Riverside Museum Press.

O'Dell, Scott
 1960 *Island of the Blue Dolphins*. New York: Dell Publishing Company.

Rindge, Frederick Hastings
 1972 *Happy Days in Southern California*. Malibu: The Rindge Family.

Rozaire, Charles E., ed.
 1977 *Indian Basketry of Western North America*. Santa Ana, California: The Bowers Museum.

Sieveking, Ann
 1979 *Cave Artists*. London: Thames and Hudson, Ltd.

Designer: Johannes Van Tilburg
Production: Johannes Van Tilburg
Coordination: Carol Leyba, Jo Anne Van Tilburg
Color supervision: Mark Oliver
Printer: Jeffries Banknote
Color separations: Jeffries Lithograph
Binding: Rogers Bindery
Typesetter: Computer Typesetting Services, Inc.
Type: Trump
Cover: Kromekote, 100 pound